CHESTER AT WORK

STEWART SHUTTLEWORTH & STANLEY C. JENKINS

AMBERLEY

First published 2019

Amberley Publishing
The Hill, Stroud
Gloucestershire, GL5 4EP

www.amberley-books.com

Copyright © Stewart Shuttleworth & Stanley
C. Jenkins, 2019

The right of Stewart Shuttleworth & Stanley C. Jenkins
to be identified as the Authors of this work has been
asserted in accordance with the Copyrights, Designs
and Patents Act 1988.

ISBN 978 1 4456 9143 5 (print)
ISBN 978 1 4456 9144 2 (ebook)

British Library Cataloguing in Publication Data.
A catalogue record for this book is available
from the British Library.

Origination by Amberley Publishing.
Printed in the UK.

CONTENTS

INTRODUCTION

C hester is well known throughout the North West, and indeed the whole of the UK, for its zoo, its racecourse, its Edwardian river frontage and its wealth of historic buildings. At night, this Cheshire city is transformed into a bustling centre of leisure with restaurants, pubs and nightclubs, while throughout the day it provides a stylish shopping centre. In 2019 service industries such as tourism, retail, public administration and financial services are predominant, and it comes as something of a surprise to discover that in the past the range of work was complex and very much broader.

Chester is situated in a strategic position on the River Dee. In prehistoric times Meols on the Wirral was the local port and trading centre. There is archaeological evidence of early small-scale settlement in Chester. The remains of roundhouses have been found under the amphitheatre and plough marks have been found on Frodsham Street from the first millennium BC. Indeed, much earlier tools from Mesolithic times were also found.

The first major development took place around AD 70 when the Romans established a legionary fortress for a legion of 5,000–6,000 men. A thriving town was laid out round the fortress, the early walls and the basic street pattern being discernible to the present day. Chester entered the Dark Ages following the collapse of Roman rule, but it later became part of the Saxon kingdom of Mercia. The former Roman city resisted Viking attacks, but there was a degree of integration between the Saxon, Viking and Celtic inhabitants of the area, and by the tenth and eleventh centuries Chester had emerged as a multicultural society and a centre of government and trade.

Chester was the last town in England to fall to the Normans. Four years after the Battle of Hastings it was devastated by the new king, who dispossessed the former Mercian landlords and made his nephew Hugh d'Avranches (the first of the Grosvenors) the Earl of Chester. In the thirteenth century Chester became the main base for the conquest of North Wales, and Richard the Engineer (the builder of Edward's Welsh castles) became mayor.

Like all cities in medieval times Chester had a range of domestic industry throughout the town, the area by the river in Handbridge being a particular focus of activity due to the availability of water power. Several corn mills were sited in the area along with other works. Silting of the river was a constant problem over the centuries, and the port's fortunes were mixed from the late thirteenth century.

In Tudor and Stuart times Chester grew again. At the time of the English Reformation, the monasteries, friaries, abbeys and convents were closed. The Abbey of St Werburgh became the cathedral, bringing fresh prestige to Chester, which became a city in 1541. During the twenty-week Civil War siege of Chester in 1645–46 further devastation took place.

Despite the canalisation of the Dee in the 1730s the port continued to decline due to silting and the rise of Liverpool. Some port-related industries nevertheless continued, and drainage of the marshes made the development of industrial Saltney possible. A reduced amount of shipping continued into the twentieth century. In the 1770s the Chester Canal was opened, but the waterway did not become fully viable until the early nineteenth century when it was amalgamated with the Ellesmere Canal and linked to the Mersey. Industrial development took place along the canal corridor and the focus moved there from the riverside, including the resiting of some milling activities from the Handbridge area. The leadworks was developed beside the canal in 1799.

The arrival of the railways later that century saw Chester's industry again refocus to its vicinity. Chester became an important railway hub with three locomotive depots, a London & North Western Railway wagon works and ancillary services. Industrial development in the station area included the Hydraulic Engineering Company, the Westminster Motor Works and Williams & Williams Ltd – a large aluminium window manufacturer.

Chester's proximity to industrial Lancashire and the Midlands perhaps stimulated the development of at least a modest industrial base. Another reason given for the development of an industrial base in Chester is that the owners enjoyed moving to the quiet atmosphere in Chester. Local workers at the same time were reluctant to move away to grimy industrial conurbations. A further consequence of the industrial development of the region was a large population seeking leisure and interesting retail opportunities, leading to no shortage of visitors.

Industrial employment became more regionally than locally focussed from the time of the railways, and certainly with the increased availability of road transport. It followed a national trend of industry moving outside of towns and cities. Workers could travel from Northgate station to Shotton steelworks or to the de Havilland aircraft factory, which became Airbus Broughton with an international portfolio. Capenhurst saw a new nuclear industry and, in the twenty-first century, the development of a new business park, which led to major financial organisations moving to Chester. In the city, Lloyds banking centre occupies part of the old leadworks site, while Capital Bank took over the old Western Command HQ. Subsequently, Chester University took over the site in their major expansion from the nineteenth-century Anglican teacher training college. A student count of 20,000 now makes them a major local employer and, with retention of graduates, is providing a huge contribution to the local skills base.

A fascinating story of work underlies the commonly held image of Chester, and in this book we will attempt to show something of it.

EARLY INDUSTRIAL DEVELOPMENT

There is archaeological evidence of the working practices in the lowland settlements that came after the hilltop enclosures in the first century BC. Pollen cores indicate that woodland clearance had begun for cereal cultivation. Simple objects like fishing hooks, loom weights and clothes pins have been found, showing that basic metalwork went on. Remnants of very coarse pottery for the salt industry have also been found.

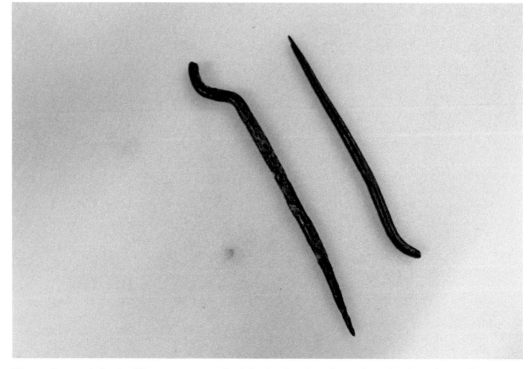

The early people in the Chester area worked the land and made tools and other objects from stone and iron. These Iron Age clothes pins were excavated at Meols. They were possibly made locally or imported. (Grosvenor Museum)

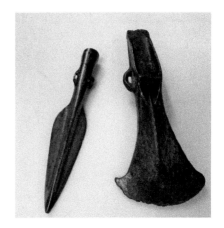

Iron Age axe and shaft head discovered as part of the Broxton Hoard. (Grosvenor Museum)

THE ROMAN PERIOD

The arrival of the Romans around AD 70 and the construction of a legionary depot put development of Chester, then known as Deva, onto a fast track. There was work constructing the fort and town, and the local red sandstone was quarried from the banks of the river for buildings and the walls.

Early evidence for the presence of industry points to leather, lead and linen as significant commodities traded from the Chester area. At Holt, 10 miles up the River Dee, there was a tile and brick works. Lead and silver extraction took place from nearby Halkyn in North Wales.

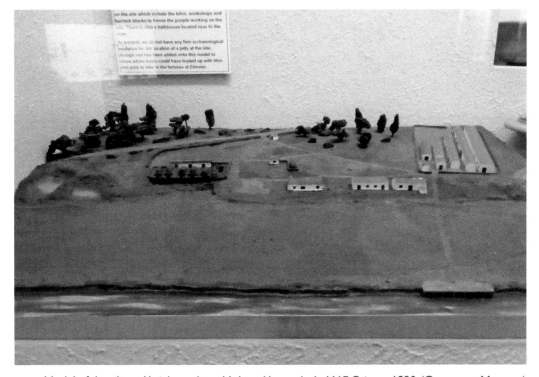

Model of the tile and brick works at Holt and barracks by W. F. Grimes, 1930. (Grosvenor Museum)

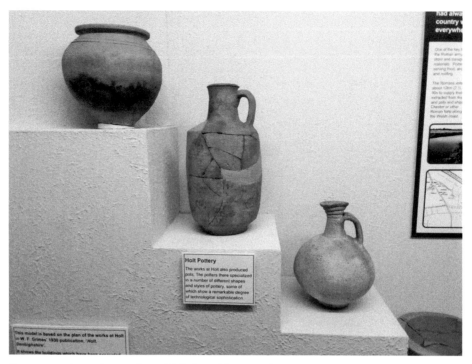

Pottery made at the works at Holt (in addition to bricks and tiles). This shows a variety of styles and technological sophistication. (Grosvenor Museum)

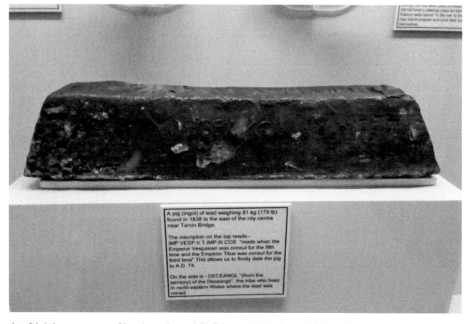

An 81-kilogram pig of lead made in AD 74, probably from Halkyn in the territory of the Deceangli tribe. (Grosvenor Museum)

ANGLO-SAXON CHESTER

Roman influence came to an end in the early fifth century. There followed a period of turmoil known as the Dark Ages in which Chester fell into decay. Several centuries later, King Alfred's redoubtable daughter Æthelflaed (*c*. 870–918) repaired and extended the walls of Chester and built the precursor to today's castle, strengthened Chester's defences and restored Chester to its former glory.

The mint at Chester is symbolic of the prosperity of the town in the times of Saxon Mercia, which the strengthened defences allowed. Its extraordinary productivity is possibly due to proximity of the Welsh mines or plunder from battles with the Danish and the Welsh princes. By the time of the Norman Conquest, although in sparsely populated agricultural county, Chester was a multicultural hub with Hiberno-Norse influences in one of the most prosperous parts of Europe.

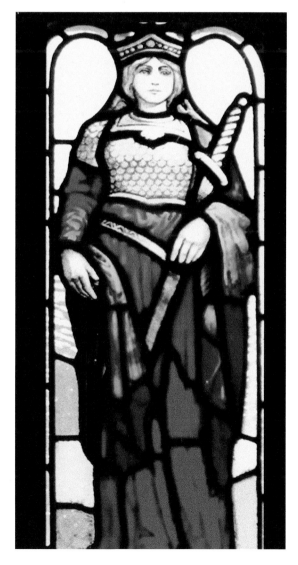

The Saxon leader Queen Æthelflaed (*c*. 870–918) is commemorated in the stained-glass windows at Worcester Cathedral.

A Saxon mould found in Lower Bridge Street, an area associated with craftsmen in those times. The faces had different-sized hollows that were used to make ingots from precious metals such as silver. (Grosvenor Museum)

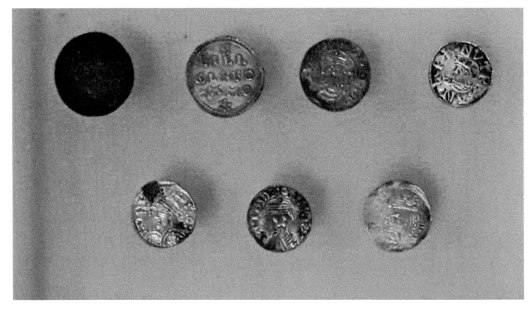

Coins were minted in Chester from Saxon times until the 1690s. Saxon coins were made by the metal being hammered into a die or mould. These coins represent both Saxon and Norman rulers, the earliest one (top left) from the reign of Æthelstan, AD 924–939. (Grosvenor Museum)

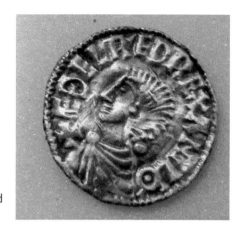

Coin with a portrait of the Saxon King Æthelred
II, AD 997–1003. (Grosvenor Museum)

CHESTER IN THE NORMAN PERIOD

In 1071 Chester became the last town in England to fall to the Normans, some four years
after the Battle of Hastings, and it is said to have been devastated by the new king. In order to
assert his rule William built a chain of castles, one of which was sited at Chester on the rocky
outcrop overlooking the Dee, which had previously been occupied by Æthelflaed's Saxon
fortification. The building of these Norman castles obviously created much work, although it is
unclear if this work was carried out by migrant Norman workers brought in for the purpose,
or by forced labour.

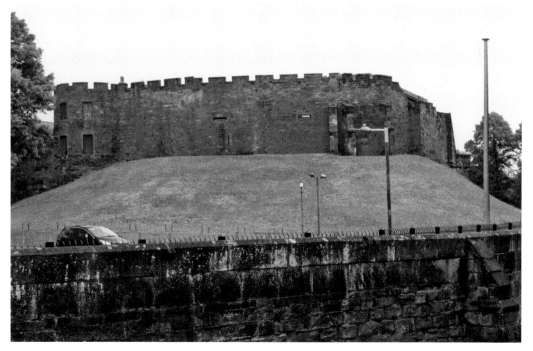

Chester Castle, a military base, prison, mint and later the administrative base for the
County Palatine.

King William dispossessed the former Anglo-Saxon landlords and handed ownership to his nephew Hugh d'Avranches, who was created Earl of Chester. The population (1,500 in 1086) worked in various industries including brewing, the working of bone, leather and metal, and the manufacture of pottery. The Domesday Book contains occasional references to localised industrial activities. A major one in Cheshire was salt production, particularly important further afield in Cheshire in the Northwich and Middlewich areas.

THE RIVER DEE

The River Dee is central to the story of work in Chester. The banks had been quarried by the Romans and joined by a Saxon bridge. In 1093 the Normans built the diagonal weir (sometimes known as the causeway) just upstream from the bridge and cut deep water channels capable of providing power for mills and for important people. The first mills were used to grind corn, but as the cloth trade developed in the early thirteenth century some of these installations were also used for fulling. By 1238 there were six local mills, rented separately from the city for the very large sum at the time of £100. From an early date a monopoly existed: all citizens, except the monks of St Werburgh's and their tenants, were required to grind their corn there and pay the earl a toll for the service.

The customs governing this were intended to benefit the city, but they caused considerable resentment, and after the death of Earl John in 1237 local unrest led to the destruction of the mills. The millers' impact on city life was considerable. In the 1260s and 1270s they held land and rents in Castle Lane and Lower Bridge Street. By the 1290s there were at least five millers, serving as judges, jurymen and pledgers in the city sessions of the county court. Some operated at the Dee Mill, others probably at the mill to the north of the town at Bache, which was owned by the abbot. It is recorded that David the Miller was especially notable. Sheriff at least twice in the 1280s and 1290s, he owned property in Northgate Street and Bache, a malt kiln in the corn market, and was tenant of all of the abbot's holdings in Bridge Street.

Another important activity was fishing in the Dee. Salmon was plentiful, although lamprey and eels were also caught. The earls assigned tithes for the fish taken to monks of St Werburgh's. In the early days of the earldom they granted the rights for boats and nets on the river to various ecclesiastical establishments, and later to an increasing number of citizens too. Salmon fishing continued on the Dee through the centuries until the beginning of the twenty-first century when the stock of fish decreased.

Chester. Dee Bridge.

From Norman times those who had the monopoly of the Dee Mills secured political power and wealth for themselves. (Len Morgan collection)

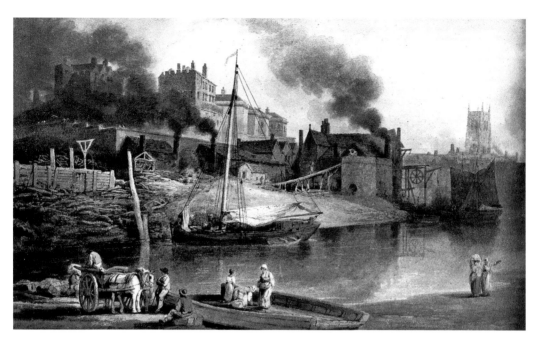

You can almost smell the industry in Francis Nicholson's early nineteenth-century watercolour of the area by the river below the castle. The painting graphically depicts animal skinners' workshops, an acid factory and wharf facilities. Trading vessels, albeit relatively small, are shown. (Grosvenor Museum)

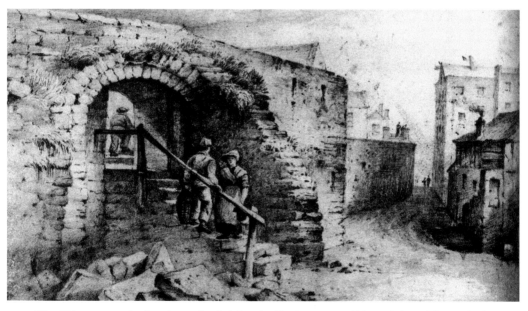

The Shipgate was in the city wall adjoining the Bridgegate on Skinner's Lane. The early drawing shows it in situ on Skinner's Lane as part of the packhorse route to St Mary's Hill. Note also the rear of the Dee Mills in the drawing. The arch consists of simple jambs, minimal wing walls and simple voussoirs to the round arch. (Grosvenor Museum)

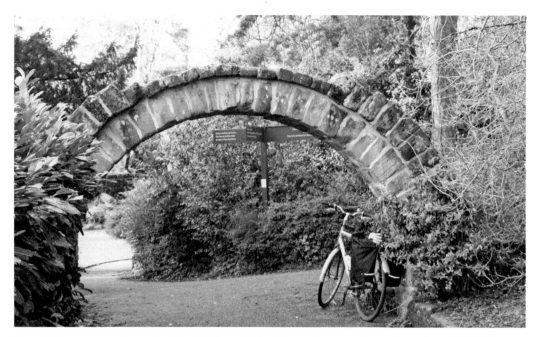

The Shipgate was dismantled in 1831 and the later picture shows it today, rebuilt in Grosvenor Park.

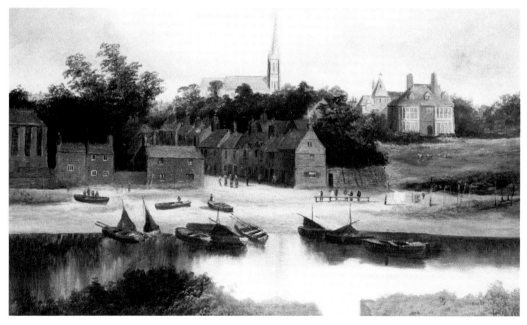

Greenaway Street, shown in this image, is where the salmon fishing families lived. Their boats are shown moored to the bank and the nets drying on stakes to the right. In the background is St Mary-without-the-Walls Church and vicarage, financed by the Grosvenors – another example of their long-standing influence over the city. The tradition was that the rector of St Mary's would receive the first (officially!) caught salmon of the season. (Grosvenor Museum)

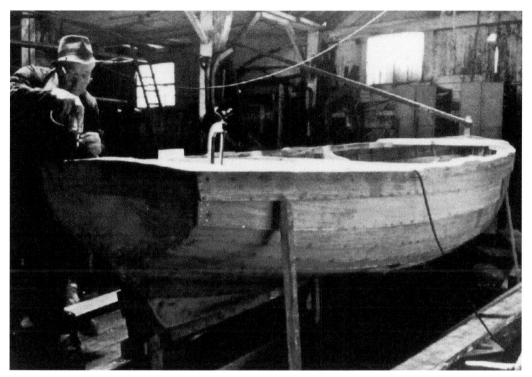

Boatbuilder Arthur Howard, J. H. Taylor's son-in-law, puts the finishing touches to one of the last three Dee salmon fishing boats built at the canal yard. Arthur was troubled that the boat was varnished rather than painted as usual due to it being destined for a museum. Had he known, he said, 'I would have used brass fastenings'. (Geoff Taylor collection)

ROYAL INFLUENCE

The earldom came to an end in 1237 when Henry III annexed it to the Crown. By 1277, Chester was the springboard for Edward I's Welsh war. The military influx had much influence on the town, and the military tradition starting in the Roman and Saxon periods continued throughout the centuries. Even today the Dale camp is still an active TA base. When not building Welsh castles, the craftsmen were employed in substantial building works across the town. Richard, Edward's engineer, was mayor of the town with an interest in the Dee Mills.

For a brief period in the late thirteenth and early fourteenth centuries, when Chester was probably at the height of its medieval prosperity, the city was the home of figures of national significance such as Richard the Engineer and William of Doncaster. By the 1230s Chester was a prosperous trading centre with a market of regional importance, two fairs and a port. Its economy continued to expand, stimulated by royal interest and its role as a supply centre for the military incursions into Wales.

The Drill Hall was designed by James Harrison as the headquarters of the 6th Cheshire Rifle Volunteers and also used by elements of the Royal Garrison Artillery. The 6th Cheshire Rifle Volunteers evolved to become the 5th Battalion of the Cheshire Regiment. The battalion was mobilised at the drill hall in August 1914 before being deployed to the Western Front. The Volunteer Street drill hall itself, being surplus to requirements, was demolished in 1983 but the façade was retained to create the frontage for some residential apartments in a building that is now known as Albion Mews.

THE MEDIEVAL CRAFT GUILDS

In the mid-fourteenth century, each group of craftsmen set up their own guilds to regulate trade and work as set out by a royal charter. The guilds played a major role in the politics, leisure and pastoral care of the town. A process of joining and splintering of the groupings went on. Each guild had its own mystery plays and there were summer shows (both revived in recent times). The guilds were grouped into those providing food, clothing or textiles and leather. A few guilds, such as the fishmongers, no longer exist. Some trades, such as fletchers and bowyers, died out when the need for their products declined.

From 1463 to 1826, there was an almost complete exclusion of imported gloves in England (so opulent and elegant Continental gloves offered rich profits to smugglers). Perth, Dundee, Yeovil, Woodstock, Worcester, Limerick and Chester became famous for 'gloving' during the Middle Ages. Chester's glovers had customers throughout Europe.

In Chester there is evidence of tanning pits dating back to Saxon times and in the Middle Ages large numbers of people were involved in the manufacture of leather and leather goods. The light leather trade was based around Lower Bridge Street, although 'Glover's Row' was located separately.

In the centre of a group of Freemen is Hilarie McNae of the Cordwainer's (shoemakers) Company, which she proudly states 'was incorporated in 1370, the earliest of the companies'. She is flanked (left to right) by freemen of the companies: Mercers (ironmongers, grocers and apothecaries), Coopers, Bricklayers and Joiners.

Freemen parade among the bands and the fantastical figures of the summer watch parade.

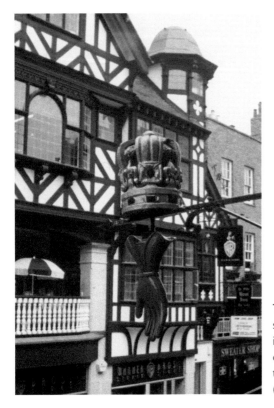

The Glover's 'Crown and Glove' sign survives on 'Glover's Row' (established in the fifteenth century), which is located on the south side of Eastgate Street, close to the junction with Upper Bridge Street. (Len Morgan collection)

This stone in a somewhat obscure corner of Water Tower Gardens is the Glover's Stone, a boundary marker for the old Gloverstone district, near the castle but outside the city and therefore importantly a free trade area. It had a darker history too in that condemned criminals were handed over at the stone from the castle to the local sheriffs for execution.

EIGHTEENTH CENTURY

B y 1700 Chester was on the verge of losing its dominance as a regional economic hub. The port had been in decline since 1600, while nearby towns, especially in south Lancashire, were beginning to develop trade and manufacturing in a manner that Chester's guild traditions and its geographical location did not allow. Some towns did not have a tight guild structure or if they did, it lost its stranglehold sooner. It wasn't until 1835 that the Corporation Acts stripped the guilds of their trading privileges. Chester was reinventing itself. There was a greater emphasis on a diverse economy based upon services, in addition to industry.

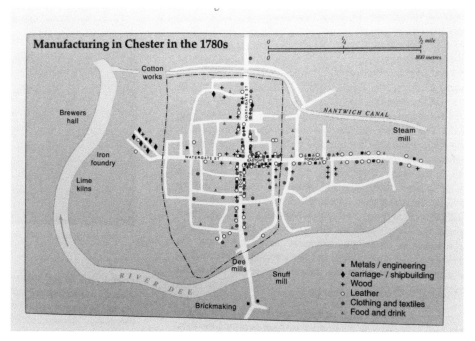

Map showing how traditional crafts were still abundant in the city in the 1780s. (Professor Stobart)

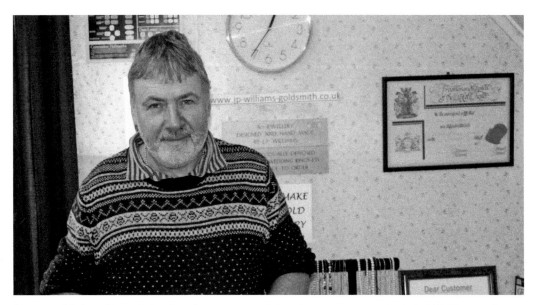

Above and below: One of the few freemen practising the company trade is J. P. Williams of the Goldsmith Company who still works in Frodsham Street. Mr Williams started an apprenticeship in Chester in 1977, completed after five years. He describes how he came into the trade: 'I started my own business when I was twenty-one in my parent's shed, got premises in Chester a short time later, and the rest is history as they say.'

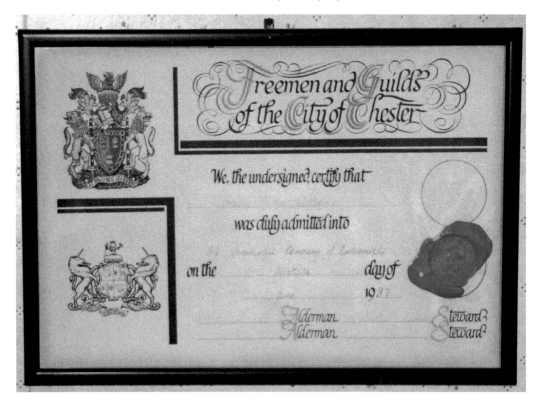

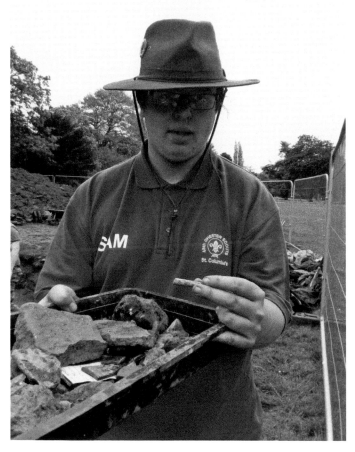

Sam, an archaeology student at Chester University, shows the fragment of a clay tobacco pipe he's found while working on the summer 'dig' in Grosvenor Park. Three pipe manufacturers are known to have worked at the nearby Roman gardens site.

THE IMPORTANCE OF TRANSPORT

River Dee traffic to Chester had been hindered by navigational hazards that, despite repeated efforts from the 1660s, were not removed. Much of the upper estuary was drained and the river canalised in new cut by the Lincolnshire engineer Nathaniel Kinderley. The cut along the Welsh shore was opened in 1737 and was largest scheme of its kind in Britain that century. Much land reclamation resulted, which may have been the prime aim. The improvements did not halt Chester's relative decline as a port but did lead to a development in shipbuilding. Several yards developed on the Roodee, downriver from the later railway bridge and at Crane Wharf. In the 1730s there were two shipyards and more followed. By 1800 the yards were so busy that twelve vessels could be seen being built at any one time with up to 250 men working on them.

The Napoleonic Wars provided further stimulus to shipbuilding on the Dee. Between 1814 and 1826 as many as 133 vessels were built and registered at Chester, the average size of these vessels being around 126 tons. Prior to the 1850s ships were built with wooden hulls, but some iron hulls were built from then on – some twenty years after iron shipbuilding had been introduced in the Liverpool yards.

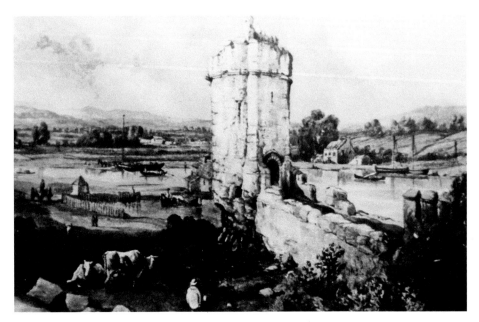

The Water Tower was built between 1322 and 1325 to defend the port of Chester. At the time it stood in the River Dee, as shown in the first image. It is attached to Bonewaldesthorne's Tower by a spur wall. The architect was John (de) Helpston who had designed castles for Edward II in North Wales. It was used to monitor the movements of shipping and to ensure that the custom dues were paid. The cost of the tower and the spur wall was £100, equivalent to £70,000 as of 2019. (Grosvenor Museum)

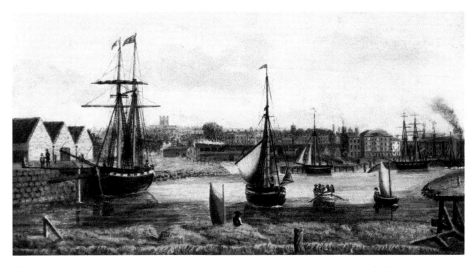

This mid-nineteenth-century painting shows the port having moved downstream to Crane Wharf. Although the canalisation of the river and the new port development meant that larger ships could again reach Chester, not all parties were supportive of the schemes. The lead exporters in North Wales had loaded their product as ballast in cheese ships further downriver. They objected to Crane Wharf developing as it incurred costs due to ships being loaded further upriver. (Grosvenor Museum)

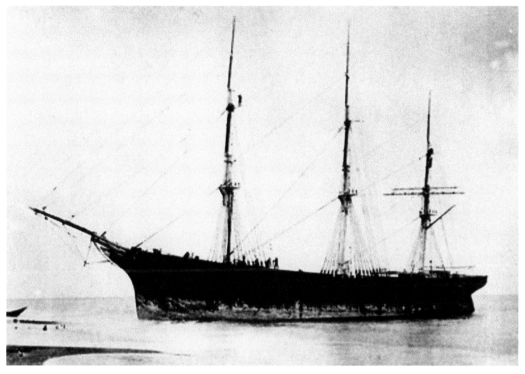

An old postcard view of the *Gitana*. (S. C. Jenkins collection)

The largest vessel built at Chester was the 1,366-ton *Gitana* in 1861, a fully rigged three-masted ship. Built by the Roodee Iron Shipbuilding Company, which employed 700 people at that time, she was an astonishing 210 feet long with a 36-foot beam. (The larger ships could be floated down the relatively shallow river only loaded with ballast, so they had a smaller draft.) After an illustrious career on charters to Calcutta and Bombay she was abandoned off Cape Horn in 1896 while on a voyage from Chile to Hamburg. Chester-built ships had a reputation for quality (and competitive pricing!), so many Liverpool merchants would commission ships from the Chester yards. The last ship was built in 1870 and the gasworks was then built on the site of the shipyard. One boatbuilder, William Roberts, continued working on the river under the castle, building smaller craft until moving to the Dee Basin on the canal in 1905.

The Chester Canal was opened in 1779, but it was thwarted from linking with the developing national canal system due to rival business interests. This meant that desired potteries and salt traffic could not be carried. Some local goods and passenger traffic developed, but was not sufficient to prevent the scheme failing. The amalgamation of the Chester Canal and Ellesmere Companies meant that Chester obtained satisfactory inland waterway links. By then Chester mainly became an intermediate point on the route to Ellesmere Port and the Mersey. Later in the 1840s the Chester Canal became part of the Shropshire Union Company, who built their main boat yard at Tower Wharf, near to the existing graving dock. In the early twentieth century this was leased by the Taylor family who had migrated from the West Midlands and had previously established a yard in the Dee Basin.

Cow Lane timber yard by the canal is shown in this early nineteenth-century painting, with the unrestored cathedral visible in the background. The yard was later owned by Musgraves, and Seddon's opened a nearby salt depot. (Grosvenor Museum)

A broad-beamed boat on the Chester Canal underneath the Phoenix or King Charles Tower, presumably drawn by the horse being led on the towpath (although no towrope is visible). The cargo appears to be sheeted up and is so high (possibly agricultural products) that you wonder if the steerer had any visibility. (Grosvenor Museum)

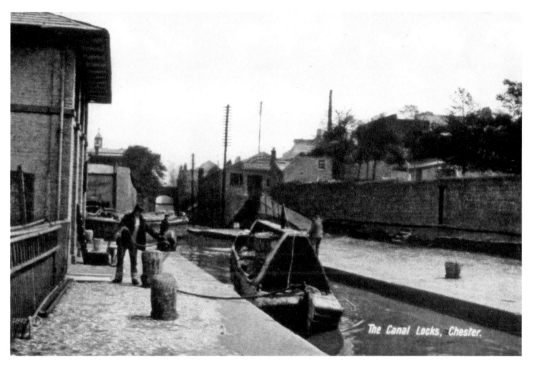

A horse-drawn narrowboat beginning to lock down the Northgate flight. A flat barge is seen in the background.

Shropshire Union bonded warehouse in Kaleyards.

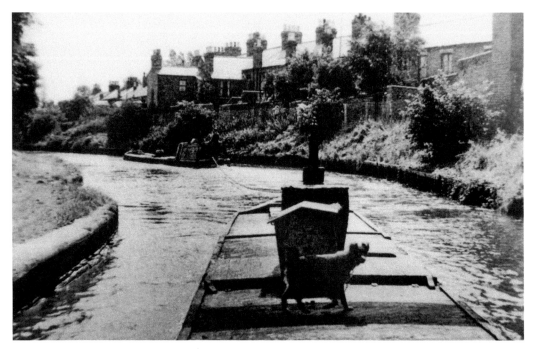

The view from the deck of the canal tanker butty (towed unpowered boat) as a 'pair' loaded with petroleum products head through what is now the Garden Quarter. (Geoff Taylor collection)

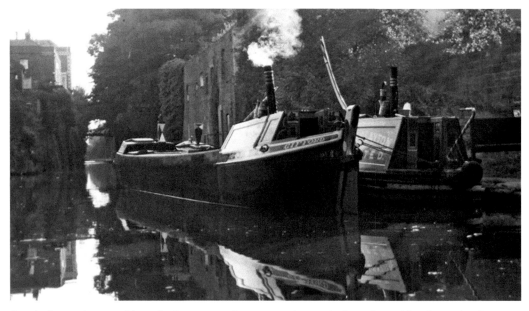

A pair (motorboat and butty) of empty tanker narrowboats tied up above Northgate Locks. They belonged to Thomas Clayton Ltd, who carried petroleum products through Chester from 1924 until 1955. They made one return run a week from Stanlow to Oldbury in the Black Country, crewed by a boating family.

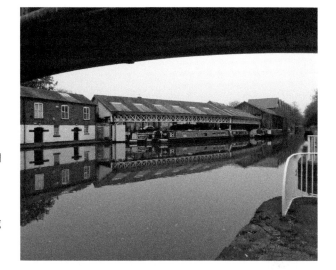

The Shropshire Union boatyard in Tower Wharf employed seventy men at its peak. The yard could handle all stages of boatbuilding, from trees coming in to the sign-written product being turned out.

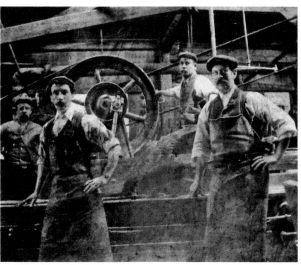

Sawyers pause from their labours in the boatyard. Fred Evans (on the right) and his family lived at Tower Wharf in one of the houses that is now part of the Telfords public house. He died of respiratory disease, possibly linked to exposure to dust in the sawmill. Fred came from Gnosall, which was also on the Shropshire Union, suggesting workers migrated around their extensive system. (Courtesy of the late Mrs James)

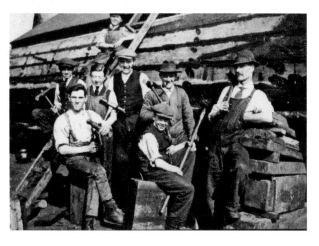

A working party sealing the seams on the wooden boat in the background at Taylor's yard c. 1920. The seams have been filled with twisted oakum using chisels and mallets (held by some of the workmen). Hot pitch is then rolled over the filled seam using the mop held by the lad centre forward. J. H. Taylor (proprieter) is on the right and a young Arthur Howard is up the ladder. (Geoff Taylor collection)

THE LEAD WORKS

Lead was the only other modern manufacturing industry to be established successfully in the Chester area between 1762 and 1840. In 1799, Messrs Walkers, Maltby & Co. set up a leadworks on the banks of the canal, the availability of water transport being an important factor in deciding the location of the new works. The proprietors were not freemen of Chester and for this reason the business was initially placed in jeopardy from a reassertion of old restrictions, which they were able to evade because some of the owners were freemen of the City of London.

The works made white and red lead for paints and built a shot tower for the manufacture of pistol balls. By 1812 a rolling mill for sheet lead and machines for drawing lead pipe had been added. The site was convenient for manufacturing lead products from ores mined, smelted and refined in North Wales, and their onward distribution in the industrial Midlands and the North West. Please see Geoff Pickard's book *Illustrated History of Chester Leadworks* for further details.

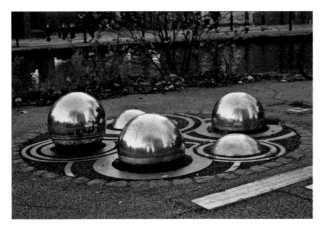

The small canalside park on Leadworks Street contains a sculpture in stainless steel and blue glass that commemorates Chester's lead industry. *Spheres of Reflection* by landscape architect Ed Snell was inspired by the lead shot tower.

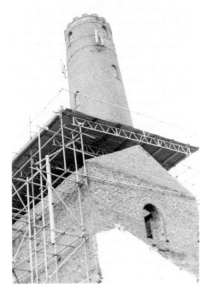

In the tower molten lead is passed through a sieve to form drops and allowed to fall. During the fall they become spherical and are solidified as they plunge into a vessel of water at the bottom. This process was invented and patented by William Watts of Bristol in 1782. The Chester documentary film *Nooks & Crannies* shows the process in action.

MILLING

Milling occupied the middle ground between the traditional and modern sectors, and was still growing in importance. At the Dee Mills there were five distinct units in the early nineteenth century. Granting tenancies separately and a stipulation banning steam engines were a disincentive to modernisation. However, in 1828 the proprietors of Ellesmere and Chester Canal took a lease over two, and most of a third mill, despite the stipulation. The banning of steam engines was a response to the fire of 1819. The fire also forced T. A. & J. Frost to relocate their milling business to a disused cotton mill on the canalside, leading to their emergence as Chester's premier milling concern. On the Handbridge (south) side there were three mills, which had started life as fulling mills (beating cloth with hammers to remove the grease and create felt). Later in the nineteenth century the Handbridge mills had varied roles.

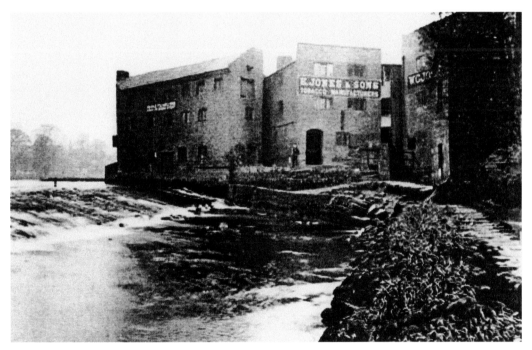

The three mills on the Handbridge bank in the late nineteenth century. The two on the bank, known as 'the fulling mills', housed E. Jones (tobacco manufacturers) at this time and W. C. Jones (fellmonger and woolstapler). The third, on the causeway itself and separated from the others by a mill race, housed Hooley's candle works. The mills were demolished by 1903. (From the collection of Chester History & Heritage as part of Cheshire Imagebank Collection – CHH)

LEISURE AND RETAIL

EARLY LEISURE ACTIVITIES

Having been rebuilt in the century following the Civil War, Chester became increasingly important as a centre for the gentry of the surrounding area to live and socialise. Its cultural life reflected this role, and the impact on the city was to emphasise its importance as a place to visit. However, the size of the amphitheatre and other Roman remains suggest that Chester was an important 'leisure and recreational' centre even during the Roman period. The amphitheatre was a focus, being used both as a venue for celebrating the many religious feasts in the legion's calendar, entertainment, public address as well as military purposes.

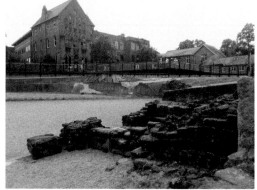

Above left and right: Two contemporary views of the Roman amphitheatre.

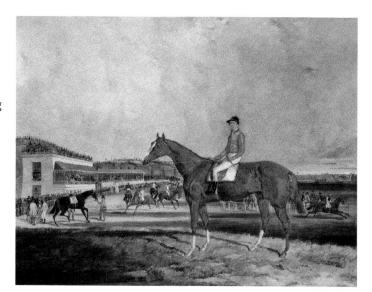

William Tasker's painting *Millipede*, which won the Chester Tradesmen cup in 1843. The race became the Chester Cup in 1893 and still runs today. It is now the high point of the third day of the May meeting, which is referred to as Chester Cup Day. (Grosvenor Museum)

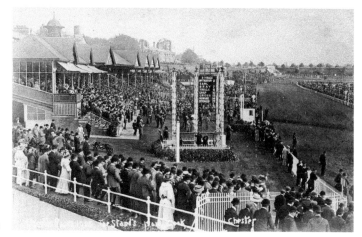

The first grandstand on the Roodee racecourse was built in 1817 and enlarged several times in the nineteenth century. It was rebuilt in 1899–1900 and again in 1985–88 after a fire. (Martin Loader collection)

The races held on the Roodee Racecourse – a 'perfect natural amphitheatre' framed by the River Dee and the city walls – were well established by the 1700s. Regular races, mainly on the 'flat', were first organised here in 1539. They have been held almost continuously ever since, making them the oldest race meeting in the country. The developing attraction of Chester for the upper classes served to foster the development of the races, and there were links with the guilds in that members of the Goldsmith's Company made the silver trophies, some of these being currently on display in the Grosvenor Museum.

Another example of an early leisure development tying in with Chester's reinvention as a fashionable social centre were the Groves. They are situated on the riverside below St John's Church. By 1717 they were Corporation property and used as a public walk, while in 1726 they were leased to a Charles Croughton, who secured the riverbank and planted an avenue of trees for the public benefit. By 1783 this riverside promenade was being called the Groves. In 1881 the riverbank from Souters Lane to the Dee Bridge was faced with rubble from the fallen tower of St John's Church, and the avenue was extended to the west.

The walls were repaired in 1707 by the city assembly at a cost of £1,000 for the repair work and the provision of a stone-flagged footway running along them. With the increasing power of cannon, stone walls could be little more than an ornament and lost their defensive function. The work in the early 1700s allowed the walls to become another promenade.

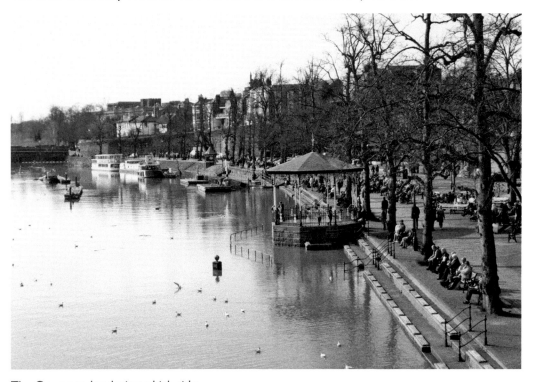

The Groves today during a high tide.

LEISURE FOR THE MASSES

The coming of the railways in the mid-nineteenth century and the rise of tourist excursions to Chester turned the Groves into a popular resort. Pleasure boats could be hired on the river by the 1850s, and in the later nineteenth century band concerts became a major attraction during the summer months. The concerts were at first arranged by a private committee, which built a bandstand in 1913, but they were taken over by the city council in 1927, when it also built kiosks for letting to traders.

Adjacent to the Groves to the north, Grosvenor Park was presented to the city in 1867 by the 2nd Marquess of Westminster with an endowment for its upkeep. It was one of the first public parks in Britain outside the big industrial cities. The park was designed by Edward Kemp, a statue of the donor was designed by Thomas Thorneycroft, and was put up in 1869 by public subscription.

The much-loved Royalty theatre became a favourite place of family entertainment for a century. It was used to put on plays and circus shows described as having little artistic merit by groups such as Madame Beatrice's Frou Frou Company. Originally called, for unknown reasons, the Oxford Music Hall, it soon changed its name to the Prince of Wales. Originally a wooden structure, it was replaced with a purpose-built, 2,000-seat brick building called the New Royalty Theatre, which was built by Bleakley & Son of Birkenhead. The first show to be given on the 27-foot stage was a version of *Aladdin* written by the first stage manager, John Bannister. The pantomime was advertised to open on 23 December, but the building was not ready. It finally opened to the public on Boxing Day 1882.

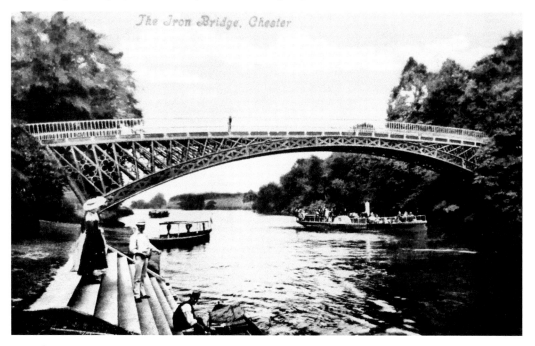

Boating excursions upstream from landing stages at the Groves, to visit the newly completed Gothic-style Eaton Hall, were an attraction by 1821. The Iron Bridge was built in 1824, linking Aldford across the River Dee with the hall. It was designed by Telford and built by William Hazeldine for the 1st Marquis of Chester. (S. C. Jenkins collection)

Above left and right: The Grosvenor Hotel was constructed in 1863–66 on a site that was first occupied by a pub known as The Golden Talbot and later by The Royal Hotel. Oddly, the Royal was the HQ of the Independent Party, political opponents of the Grosvenor family. The building was designed by the Chester architect Thomas M. Penson (1818–64). The upper façade of the building is a distinctive half-timbered black-and-white structure, in the Tudor revival style that is typical of Chester architecture.

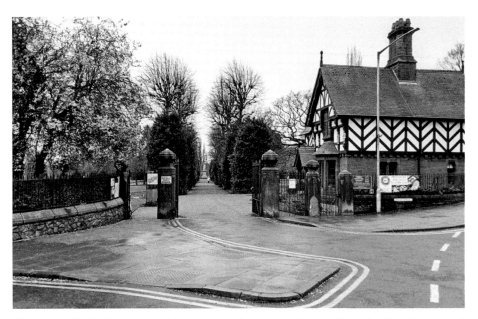

Grosvenor Park's black-and-white entrance lodge was designed by John Douglas, one of the triumvirate of well-known local architects.

Above and below: The Royalty Theatre was built on the site of an earlier wooden building that had started life as a sort of canteen and possibly accommodation for the workmen building the General railway station nearby. (Len Morgan collection)

The significance of tourism to Chester's economy continues to increase. Chester Zoo, on the north-eastern outskirts at Upton Heath, is on of the biggest tourist attractions in the North West, but it only entices a limited number of visitors into the city centre. Within the city the most visited places are the cathedral, the city walls and the Rows.

RETAIL ACTIVITIES

Chester had traditionally been regarded as a trading centre and supply base for military campaigns into Wales, and for this reason retailing was an important activity within the city from the earlier thirteenth century. Chester had total dominance over an extensive rural hinterland, while its twice-weekly market was without serious rival between Derby and Lancaster. By the thirteenth century Chester's Midsummer Fair lasted a month, and the Michaelmas Fair a fortnight. Retailing activities took place not only from market stalls but also from permanent premises, which were already being called 'shops' (*shopae*). The shops were generally small. By the late thirteenth century, they were on two levels in the main streets, in the unusual arrangement already known as the Rows. These were surmounted by covered walks or galleries at first-floor level.

Shops were, from the very first, often grouped by trades. Especially prominent among the retailers were the purveyors of victuals. The butchers, who profited from the demand created by the garrisons of the royal castle, were numerous and well organised and seem to have enjoyed comparatively high status. The spicers and vintners were of even higher status. In the later thirteenth century members of both groups served in the judiciary.

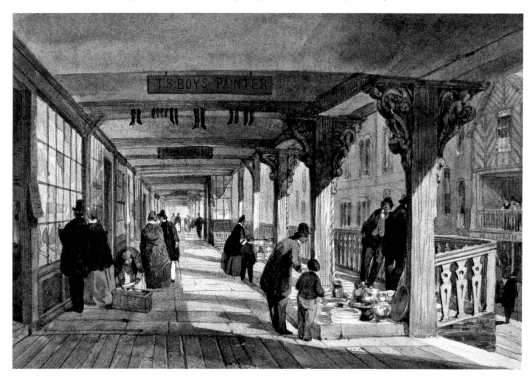

Watergate Row South in 1862 with the raised stallboard being used for the display of goods. (Grosvenor Museum)

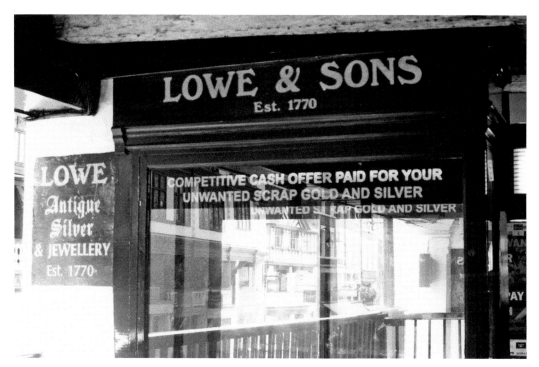

Lowe & Sons has been trading from these premises in Bridge Street Row since 1804.

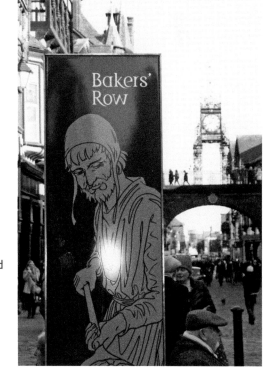

This panel in Foregate Street locates and describes Bakers' Row. Craftsmen involved in the same trade often worked in the same part of town. Shoemakers' Row was in Northgate Street, Mercer's Row in Bridge Street Row East and the Skinners' Houses were between the castle and the River Dee.

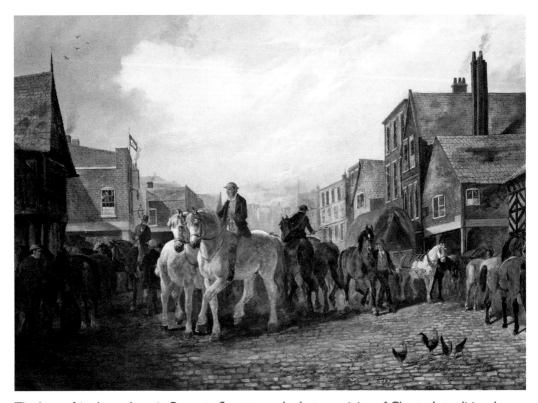

The horse fair shown here in Foregate Street was the last remaining of Chester's traditional fairs held in a street. Pressure from shopkeepers had forced livestock fairs off the streets and into specialised cattle markets. The development of wholesalers and retailers through the nineteenth century had made the cloth fairs obsolete. Horse fairs continued in Foregate Street until around 1880. They ceased due to pressure from the street's retailers and the tram drivers for whom the presence of numerous horses, sellers and buyers blocked the lines of the horse-drawn trams. (Grosvenor Museum)

THE HIGH STREET DEVELOPS

Retail opportunities became a huge part of Chester's visitor appeal. The creation of Jacobean-style black and white buildings in the town centre (begun in the 1830s) was the most dramatic in any English city. Eastgate Street was compared with London's Oxford Street and Brown's, the leading department store, was nicknamed 'the Harrods of the North'. By 1914 the vernacular revival had ended, but the Victorian redevelopment of Eastgate, Northgate and Bridge Streets had transformed a modest city centre into a shopping centre of metropolitan appeal.

The vernacular revival in Chester was not without its critics and the architect W. T. Lockwood made a determined, though ultimately unsuccessful, stand against it. In 1910 he was responsible for the most controversial building erected in Chester for half a century: the St Michael's Row development in Bridge Street for the Duke of Westminster. The arcade is an early elevated shopping street.

A Greek revival building from 1828.
It became the first part of Brown's
department store.

Department and chain stores were increasingly represented in Chester's shopping centre after 1871, though smaller local businesses continued to be important. Brown's was established in 1780 by Susannah Brown and moved to its current site on Chester's Eastgate Street in 1791. The Brown family remained Chester's premier shop owners. It remained a family firm until 1907 when the two component businesses were combined to become a limited company. Before then the two components of the business – clothing and house furnishings – were run separately. The profits of the clothing store, which traded as Brown, Holmes & Co., were 'sluggish' due to a focus on a small, albeit wealthy, clientele. In the 1890s, the firm modernised, offering daring new lines for the times, such as tennis costumes and cycling clothes for women. They advertised more aggressively and aimed at a broader client group. In 1909 both the drapery and furniture departments were renovated and in 1914 Browns was clearly Chester's leading modern department store. In 1961 they still employed 600 people. It was acquired by Debenhams in 1976. Brown's is the only store in the group to retain its own trading name, alongside the standard 'Debenhams' branding.

In the early 1950s retail sales per head of population in Chester were far higher than in any other comparable town or city elsewhere in the country. There had been a revival of the tourist trade after the war, Chester combined visitor appeal with retail opportunities. Retailers employed over 5,000 people, and retail-type services such as catering and garages another 2,000.

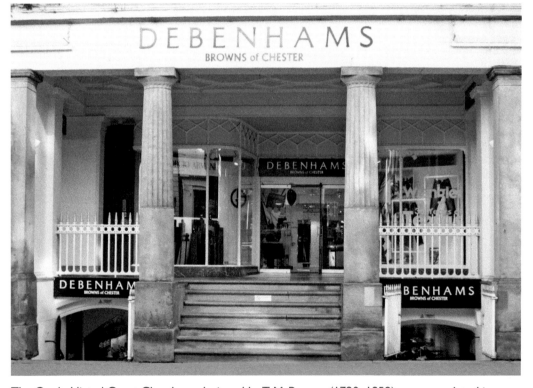

The Grade I listed Crypt Chambers, designed by T. M. Penson (1790–1859), was completed in 1858. The building incorporates part of the Chester Rows. The Gothic façade is built over a medieval undercroft dating from the twelfth century, which contains a tea room with a Greek revival building from 1828.

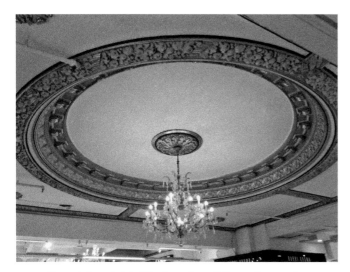
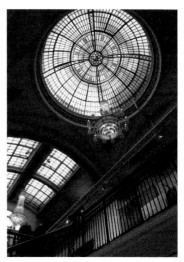

Above left and right: The interior of Brown's contains many ornate features such as glass-domed roofs and elaborate plasterwork surrounding chandeliers in the main entrance area. Some of the glass roof on the second floor has been concealed as it was covered by the construction of the third-floor extension containing the main Café and Kalmora Spa. It can still be seen by carefully looking through the suspended ceiling now covering it.

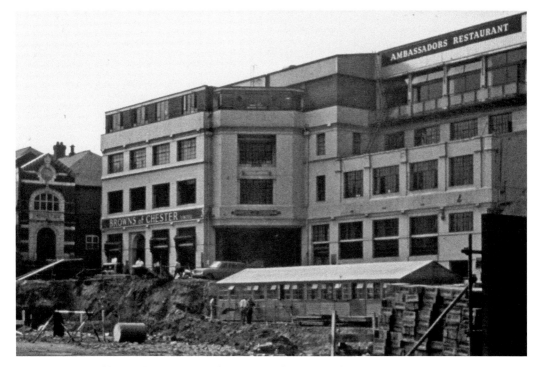

The rear of Brown's was exposed when the Grosvenor Shopping centre was being built.

THE FORUM CENTRE

Cestrians are particularly sensitive about buildings near the cathedral and Town Hall. Already 'sore' from the demolition of the baroque market hall in 1967, they were incensed by the appearance of the Forum Centre. In 1993 it was called 'perhaps the worst piece of modern urban planning in the centre of any historic city in England'. The planners capitulated, and in 1993–95 the cantilevered upper storeys were cut back and a new façade, more subdued in colour and post-modern classical in style, was applied by Leslie Jones. However, they couldn't win: the refurbishment was described as 'superficial, facadist and motivated more by commercial considerations than by civic pride. A wasted opportunity to revive what should have been Chester's civic and cultural heart'.

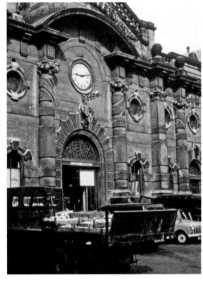

Left and below: The Victorian market hall was demolished in 1967 and replaced by the Forum. (Len Morgan collection)

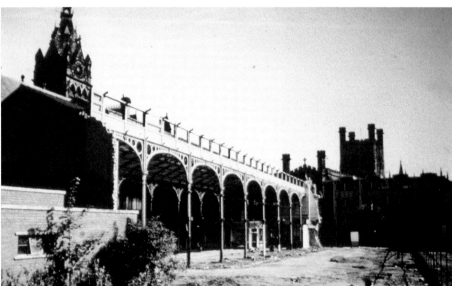

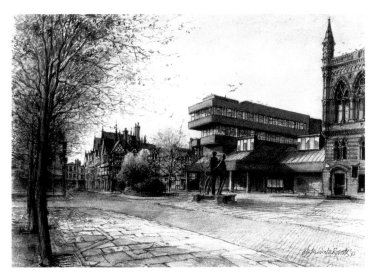

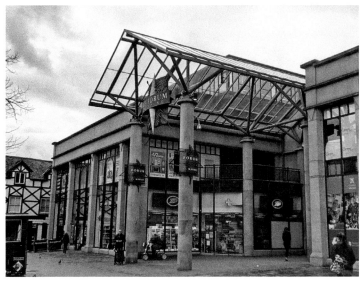

The Forum before and after the 1993–95 modifications. It was designed by Michael Lyall Associates in the brutalist brick-clad style made fashionable in the 1960s. It included council offices and a shopping mall and was delayed by archaeological excavation until 1969–72. It had council offices boldly cantilevered over the Northgate Street entrance to the new shopping mall. (Grosvenor Museum)

OUT-OF-TOWN SHOPPING CENTRES

From the mid-1990s, new out-of-town shopping developments threatened to dominate Chester's shopping centre. The Cheshire Oaks, an 'outlet mall' at Ellesmere Port, opened in 1995 and extended in the later 1990s, was the largest project of its kind outside North America. Broughton Park was opened in 1999 in a part of north-east Wales that had hitherto looked almost entirely to Chester for shopping. Chester's own, the Greyhound and Chester retail parks, both on the edge of the city with nineteen and six stores respectively (although small), significantly competed with the city centre.

INDUSTRIAL DEVELOPMENT 1840-1900

Modest new industries were appearing and developing as the nineteenth century progressed, notably steam milling, ironfounding and the leadworks, while craft employment remained a very important element of Chester's economy. The most important trades were tailoring and shoemaking. The related activity of ropemaking survived throughout the nineteenth century, but only forty-two men worked in the trade in 1831.

Other traditional industries such as tanning, for example, barely retained a foothold, the number of tanneries having dropped from seven to two. However, the riverside mills – two on the bank of the river known as the higher and lower Fulling Mills, and the third which was on the causeway itself and separated from the others by a mill race – continued for various purposes until demolition in 1903. Service employment, especially domestic service, predominated for women, whereas for men the largest sectors were manufacturing and craft employment.

By 1840 many of Chester's older and wider trade connections had withered, and the city had been forced to adopt a diminished role servicing the local region. The Roodee and Crane Bank shipyards were in operation until 1869, but shipbuilding did not return to the Roodee after the 1869 closure, and the surviving local boatbuilding firms were relatively small. William Roberts's yard, building working boats and pleasure craft, operated on the river under the castle until around 1906 when it moved to the Dee branch canal basin. The Shropshire Union Canal Co. built narrowboats and Mersey flats at Tower Wharf until 1913 and the yard was taken over by J. H. Taylor & Sons in 1917.

THE COMING OF THE RAILWAYS

Chester's heavy reliance on providing services for its hinterland implied a dependence on its fortunes and the need for improved transport connections. The railways provided the means by which that could be achieved. The first railway to Chester from Birkenhead opened in 1840, followed just over a week later by the Crewe line. There was a modest stimulation of industry over the next thirty years. The nearby Gorse Stacks and Brook Street area developed as the main industrial centre on the edge of the older urban core. Foundries, engineering works, saw mills, tanneries, and a chemical works were situated there.

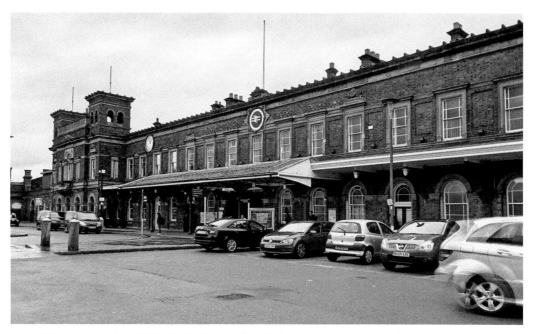

When opened in 1840 the Birkenhead and Crewe lines terminated in separate stations. In 1848 the General station was opened to serve four railway companies. It was designed by Francis Thompson and is Italianate in style. The station is one of the most stunning early stations in the UK.

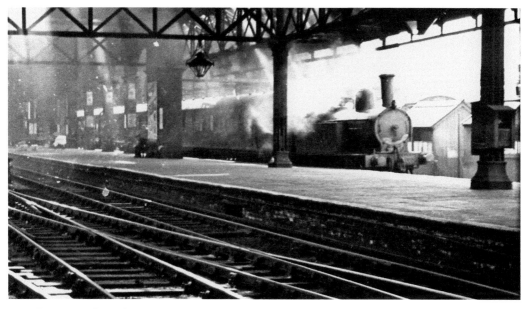

In steam days, the interior of the station was a somewhat gloomy place, as exemplified by the accompanying *c.* 1930s photograph, which shows a London & North Western Railway tank locomotive shrouded in steam beneath the smoke-blackened roof girders. (S. C. Jenkins collection)

Henry Lanceley, Son & Co. was typical of engineering firms in Chester. It grew modestly in the late nineteenth century by exploiting opportunities in the region, and had a turnover of £10,000 in 1908–09. Founded around 1869, the firm started in a small way in George Street, but after a move to larger premises in the same street. In the mid-1880s it took over a former tannery in Brook Street and converted it into the Providence Foundry and Engineering Works. In 1881 Lanceley's was largely concerned with satisfying the jobbing engineering requirements of other Chester enterprises, but it dealt with an extremely wide range of customers and activities ranged from repairing mangles to supplying complete steam engines and boilers. By 1909 the volume of business had almost doubled and around half was from outside the city. In the 1900s Lanceley's benefited from the growth of John Summers's steelworks at Shotton and the sheet metal industry at Ellesmere Port, but the firm also carried out contracts along the North Wales coast, in the north-east Wales coalfield, and in the rural areas south-east and east of Chester.

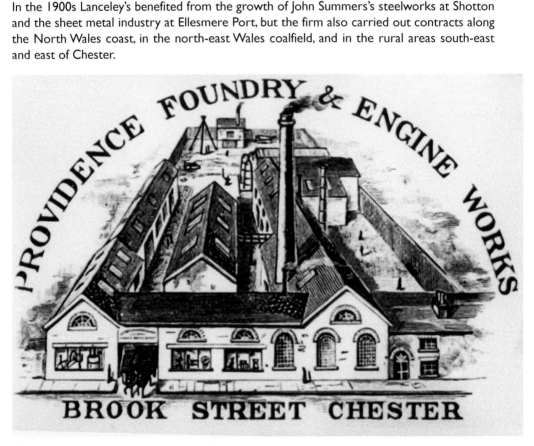

The Providence Iron and Brass Foundry of H. Lanceley and Son, founded in George Street around 1869, moved later to a group of mostly single-storeyed buildings on the west side of Brook Street previously used by a tannery. The frontage is now that of Maltby's carpet shop. (CHH)

The Egerton Iron and Brass Foundry, operated by James Mowle & Co. in 1871, and Mowle and Meacock by 1892, lay between Crewe Street and Albert Street. The foundry had been demolished by 1910 when Egerton Street School was built on the site. Mowle and Co. appear to have partly specialised in lead-manufacturing equipment (they were quite close to the leadworks) as in 1880 they provided a horizontal single-cylinder steam engine driving a lead rolling mill at Sheldon, Bush and Patent Shot Co., Bristol.

J. E. Brassey & Son of Foregate and St John Street were one of largest employers in 1910 with 210 staff.

This still surviving three-storey building on Egerton Street was originally a sawmill belonging to Lockwood and Farrimond. It incorporated offices at the street end and works with an arcaded ground floor at the rear. Built in the mid-nineteenth century, it was occupied by paint manufacturers in 1906.

The Hydraulic Engineering Company (HEC) is an interesting example of a company that flourished in Chester at this time to become an industry leader. The business stemmed from the Flookersbrook Foundry that had been established by Messrs Cole, Whittle & Johnson in 1805. In 1869 Edward Bayzand Ellington, later known as 'Mr Hydraulic', joined the company as a partner with Bryan Johnson and became the managing director. He had other associated interests, including the London Hydraulic Power Company, which was one of the first companies in the world to provide a high-pressure water system to public services by means of a network of pumping stations and underground pipes – the idea being that this infrastructure would provide on-site power for factories or other premises in the same way that an electrical network might function. The system was adopted in various parts of London and Liverpool and almost all the steam engines and pumping plant needed were designed and manufactured in Chester. By then foundry work had long since given way in importance to engineering.

The HEC made a significant contribution to the war effort during the First World War, when it manufactured machinery for making armaments. Their contribution was recognised by a visit made by George V and Queen Mary in May 1917. The Hydraulic Engineering Company undertook the construction of hydraulic installations for the Great Western Railway, the Mersey Docks & Harbour Board and the Port of London Authority. The Hull Docks System, Tyne Docks and the naval dockyards of Chatham, Devonport and Portsmouth, all utilised hydraulic machinery built in Chester. The company also operated internationally, building port installations for use in places as far afield as Gibraltar, Malta, Hong Kong, Bombay, Calcutta, Karachi, Melbourne and Barcelona.

A view of the Charles Street entrance to the Hydraulic Engineering Company. (CHH)

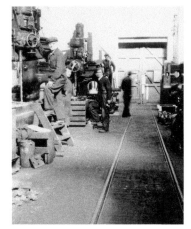
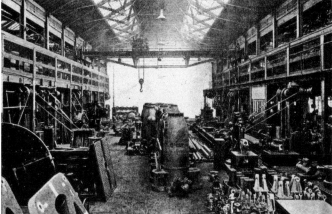

Above left: Inside the HEC No. 3 machine shop around 1950. Fred Penney works on a radial arm drill. Drilling and milling were semi-skilled, while turning was skilled work. (CHH)

Above right: Inside the HEC erecting shop in 1892. There were iron and brass casting landings either side. (CHH)

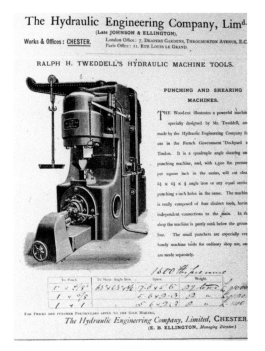

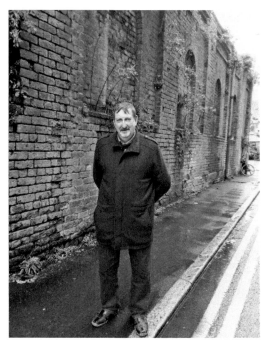

Above left: An early HEC advertisement (possibly from the 1876 catalogue) for a shearing machine. (CHH)

Above right: Robert Griffiths revisits the last remaining building of the Hydraulic Engineering Company in Charles Street. He remembered 'the large, awkward loads of finished engineering products negotiating the gates'. Robert worked for the company from 1969 to 1984, starting as a technical apprentice. Initially he was fitting, then moved into the drawing office, which he says 'was very modern for its time'. Having learnt the skills of the draughtsman he ended up tendering for work. Robert has fond memories of the engineering precision of the manufacturing work there and the comradeship.

GENERAL DEVELOPMENT

Chester's largest industry, the leadworks, covered a large area by 1873. Frost's Steam Mill acquired additional buildings in the later nineteenth century, at first on the west side of Steam Mill Street and then on the east side, with the two parts being connected by a high-level bridge. The eastern additions, which were of three or more dates and had decorative architectural elevations to the north, were almost complete by 1873. The final additions appear to have been a south-east extension, demolished by 2000, and an office building of 1891 to the south-west.

In City Road, the shoe factory of Messrs Collinson, Gilbert, & Co. was built between 1864 and 1866 as a four-storey building with elevations of ten bays and closely spaced windows to the north and east, in a style redolent of the early nineteenth century. It was described as housing 'vast amounts of machinery' and employing 250 hands who turned out 2,000–3,000 pairs of boots a week. Collinson did not, however, stay in manufacturing. Around 1875 the factory was taken over by Alfred Bostock & Co., a Stafford shoe firm until 1892. The premises were then occupied by Mr Harker rope and twine manufacturer and chandler.

From the late nineteenth century the view along the canal was dominated by the leadworks and a line of corn mills and related premises. Today the same mooring is used by the restaurant boat. Ironically it has similar dimensions to the 'flat' but with a very different function. How times have changed! (CHH)

The steam mill was built by Frosts the millers in 1834, who had moved from Dee Mills on the river in 1819 to an old canalside cotton mill. They moved in 1910 to Ellesmere Port. The building was then taken over by Miln's Seeds. A blown air seed transport system was used inside.

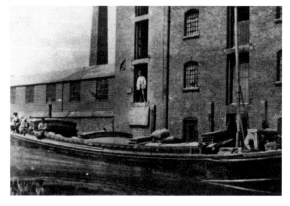

A canal barge locally known as a 'flat' unloading at what is now the Mill Hotel. Today the same mooring is used by the restaurant boat. Ironically it has similar dimensions to the 'flat' but with a very different function. How times have changed! (CHH)

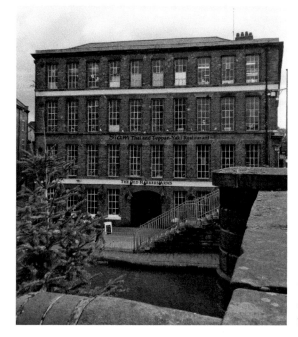

The Old Harkers Arms was originally built as William Collinson's footwear factory.

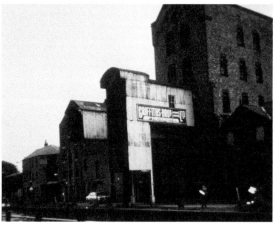

Near Frodsham Street Bridge lay the Queen's Wharf premises of Griffiths Brothers built in the mid-nineteenth century. They were expanded in the 1870s and again in 1912, and their gaunt five-storeyed buildings, with small iron-framed windows and loading gantries spanning the canal towpath, were a striking feature of the area. (Len Morgan collection)

Further west in Seller Street lay the Albion Mill. Founded in 1868–69, it included a long four-storey building of red brick with iron window frames. Nearer to the city centre was Wiseman's Cestrian Corn Mill (Mill Hotel) on Milton Street. The oldest part of which, with a tall chimney, was built in the 1850s. By 1873 a narrower six-storey block had been added to the west. Finally, nearest Frodsham Street Bridge lay the Queen's Wharf premises of Griffiths Brothers, which seems to have originated in the mid-nineteenth century.

IMPACT OF THE RAILWAYS

By 1870 the city was a focal point in the regional rail network. In 1861 the London & North Western and Great Western Railways were the two biggest employers in the city, these two companies having extensive wagon works on both sides of Brook Street adjacent to General station. Most of the railway workers, both skilled and unskilled, seem to have initially been recruited from an existing national pool of labour rather than being newly trained local men. Such migrant workers added new spending power to the Chester economy even though many were unskilled and relatively poorly paid.

By improving Chester's links with its hinterland the railways in their first thirty years, enhanced the prospects for manufacturers and at least some retailers – the lead works, for example, became rail served. There were certain disadvantages: the large, relatively undeveloped area of land occupied by the railways formed a barrier that inhibited expansion in that direction. The situation was exacerbated by several railway companies competing with each other rather than sharing facilities.

Northgate station and locomotive depot opened in 1874 due to railway development continuing throughout the Victorian period. It was part of the Cheshire Lines Committee and initially served Manchester trains but was extended west in 1890. The site is now the Northgate Arena leisure centre. The line was extended westwards in 1890, and it incorporated Liverpool Road station. (CHH)

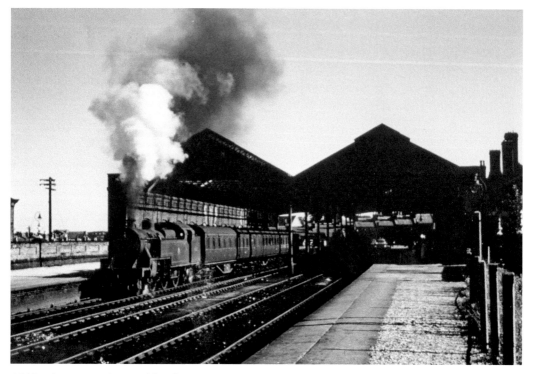

A Wrexham train departs Northgate station.

Tommy Jones proudly displays the hammer he used as a wheeltapper in 1954 at Northgate station. He describes being trained by a Mr Bill Lapworth. Tommy said 'at first you had to walk behind Mr Lapworth carrying the tools. Next you could walk alongside him. Finally you could call him Bill'! After eight weeks of training he was assessed and became the carriage and wagon examiner at Northgate.

Peter Clark holds a model (renumbered by him) of a locomotive he fired while working at Northgate shed. He started there as a cleaner aged sixteen in 1953. Due to it being a small shed he progressed to firing within a few months. His duties included the racehorse special (the horses were walked to Linenhall stables from the Northgate station) and the cattle train from Bidston Docks. On the push pull service to Buckley for summer's steelworkers, the fireman would occasionally be allowed to drive. On one occasion between Saughall and Sealand they touched 84 mph. Peter said 'the work on shed preparing locos and dropping fires was terribly dirty. It caused me headaches, which the doctor said was due to the dust'. When Northgate shed closed he moved to the 'Western'. He said 'a poor job on the Western was the Birkenhead … stop, start. The only good job was working the express to Wolverhampton'. Peter did national service between 1956 and 1958 and left the railways with indelible memories in 1962 for a job with GPO telephones.

PUBLIC ADMINISTRATION AND FINANCIAL SERVICES

Throughout the ages, public administration has been a major source of employment in Chester. Chester was the seat of government of the County Palatine, whose offices were based within the castle. The county exchequer and court were also based there until 1850. The offices remained there on the formation of the county council in 1888 until County Hall was opened on 11 July 1957 by the Queen.

Work on the Neo-Georgian County Hall started in1938 but it wasn't until 11 July 1957 that it was officially opened by the Queen (work ceased in the period 1940–47, delayed by the war). It was designed by E. Mainwaring Parkes, the county architect and occupied the site of the old prison and Skinner's Lane. The materials with which the building was faced, Wattscliffe stone and Stamforstone grey-facing bricks, were chosen in 1938 for a fee of 100 guineas by Sir Giles Gilbert Scott. The stone coat of arms above the main entrance was carved by the Liverpool sculptor H. Tyson Smith. It was vacated when the county council was divided into the two unitary authorities. Later it was sold to the university for a controversial £10 million.

The HQ building was built at a cost of £21 million. A part of it houses the new CWAC unitary authority.

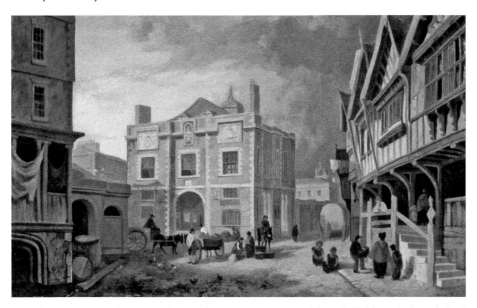

The Exchange was built in Market Square between 1695 and 1698 and demolished after a fire in 1862. The Corporation used it for meetings and courts. There was also an assembly room for social events. (Grosvenor Museum)

Chester Corporation was housed in the Pentice from 1506 until 1803. This was a wooden structure attached to St Peter's Church and therefore on the site of the Roman Principia. The Corporation moved to the Exchange, which burnt down in 1862. In 1867 they moved into the Town Hall. To this day Chester continues to be a centre of administration for the Cheshire West & Cheshire Council (CWAC), formed in 2009 as a result of several boundary changes. CWAC is now one of four unitary authorities within the old county. The latter still exists as a ceremonial county with a high sheriff and a lord lieutenant.

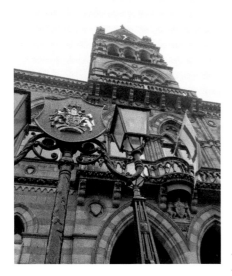

The current Town Hall, built in 1865–69 replacing The Exchange. It was designed by W. H. Lynn of Belfast and inspired by the Cloth Hall at Ypres. (Grosvenor Museum)

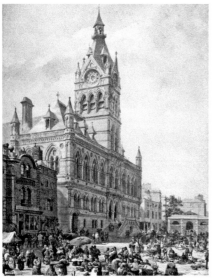

FINANCIAL SERVICES

The increasing importance of shops was paralleled by the development of banking and other service activities. Local banking became established, though it was often a risky business. Thomas & Hesketh's Bank became insolvent in 1793 and Rowton and Morhall's lasted for only a few years until its failure in 1810. Owen Williams established the Chester Old Bank in 1792 and it survived to become Chester's premier bank for much of the nineteenth century. It was joined in 1813 by Dixon & Co., which had strong Liverpool connections. William Wardell joined the bank from Liverpool in 1829 and he remained a leading figure in the commercial and political life of Chester until his death in 1864. The Chester Savings Bank was established in 1817.

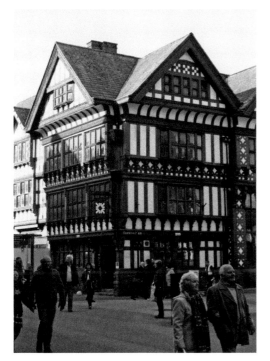 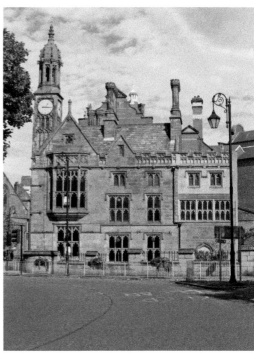

Above left: The Royal Bank of Scotland on Foregate Street is a very late half-timbered building. It was built in 1921 for the Manchester and District Bank by Francis Jones and extended in 1964.

Above right: The Trustee Savings Bank was established at Chester in 1817. The bank was housed in the Exchange until 1838, when new premises were leased in Goss Street. In 1851–52, this new building, designed by the architect James Harrison (1814–66) was erected in Grosvenor Street.

In the last quarter of the twentieth century the city again became important as a provider of financial services through the arrival of several national firms. Many older and much smaller providers of financial and professional services continued to occupy offices in the city centre. In 1990, for example, Chester had at least twenty firms of accountants, twenty-one of solicitors, eleven of architects, thirty-seven insurance brokers, and ten advertising agencies. The three largest firms of consulting engineers and the two largest estate agents each employed over 100 people. Several large firms new to Chester were attracted to the privately developed business park, which opened in 1988 on 150 acres to the south of the city. Among the first was the administrative headquarters of Shell Chemicals UK, whose domestic-style pavilion with a hipped roof by Leach Rhodes and Walker set the pattern for most of the subsequent buildings. Other notable buildings were those for Marks & Spencer Financial Services by Aukett Associates, and the palatial Palladian-styled complex, which by 1999 could accommodate up to 2,000 employees of MBNA International Bank, the British arm of a large American bank.

Other firms that set up at the park included the business services of the pharmaceutical company Bristol-Myers Squibb, and Trinity International, a holding company with interests in regional newspapers, paper and packaging which bought the Mirror Group of newspapers in the late 1990s and became Trinity Mirror plc.

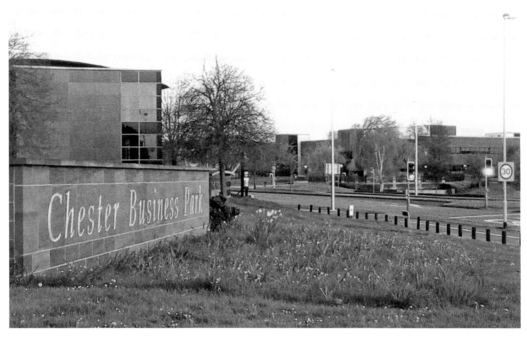

The privately developed business park opened to the south of the city in 1988 has become a major employer.

The business park incorporates the original John Douglas-designed Hawarden Farm (which became offices).

Office accommodation for several hundred small businesses was provided by the refurbishment and development in the 1990s of the Steam Mill and the Enterprise Centre in a large redundant goods shed near the station. The growth of financial services provided a very large number of managerial, administrative, clerical and call centre jobs. In Chester district their number grew from 10,800 in 1991 to 15,000 in 1997.

One particularly important firm of local origin was North West Securities (NWS). It originated as 'Improved Financial Limited', established to provide car loans. In 1948 it moved into Chester and changed its name to NWS. It was purchased by the Royal Bank of Scotland who invested considerably in it. By 1971 there were fifty-six branches across the UK. It was renamed Capital Bank in 1997. In the 1970s and 1980s it continued to grow and diversify by operating financial services on behalf of other organisations such as the Automobile Association and the National Farmers' Union, employing 4,500 people in 1997 and almost 6,000 in 1999. It built two further office blocks in City Road in 1987–88 and a training centre at the business park, and in the later 1990s refurbished the former Western Command building as its headquarters, which overlooks the Dee from Queen's Park.

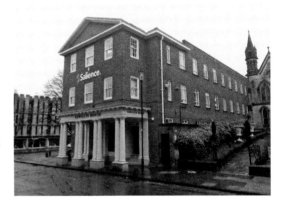

Norwest House on Newgate Street was built as NWS's new head office in 1956. They had premises at No. 19 since 1948 when they moved from Colwyn Bay.

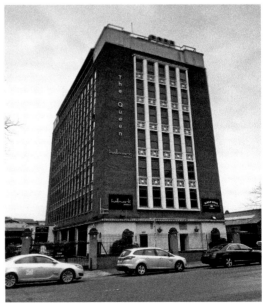

The mayor opened NWS's office block in City Road in June 1963.

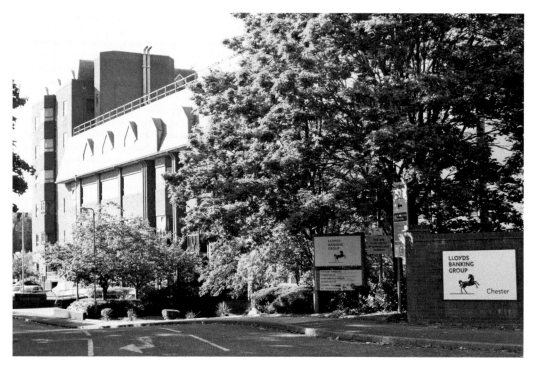

Now owned by Lloyds, this building on the old leadworks site was built by the Capital Bank for its telemarketing operation.

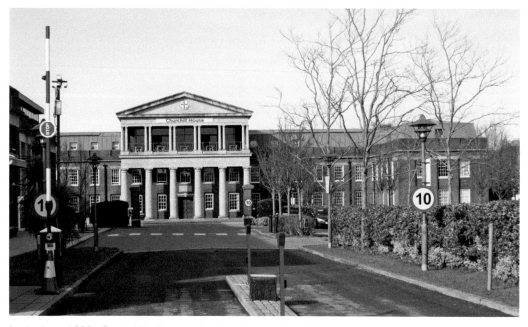

In the later 1990s Capital Bank moved to the former British Army Western Command building of 1938 overlooking the Dee in Queen's Park. They refurbished it as their headquarters, adding a portico.

UTILITIES AND TRANSPORT

WATER SUPPLY

In Roman Chester water from the springs at Boughton had been carried into the town along a series of clay, lead or elm pipes (formed from hollowed-out trees). Later, in the thirteenth century, water was piped to a cistern in Bridge Street by Chester Cross. In 1600–01 a square tower was added to the Bridgegate that contained machinery for lifting river water into the town. This was known as John Tyrer's Water Tower, after its builder, but the tower was destroyed in the siege of Chester in 1644–65. It was rebuilt as an octagonal tower, but was demolished for a second time when the new gate was opened in 1781.

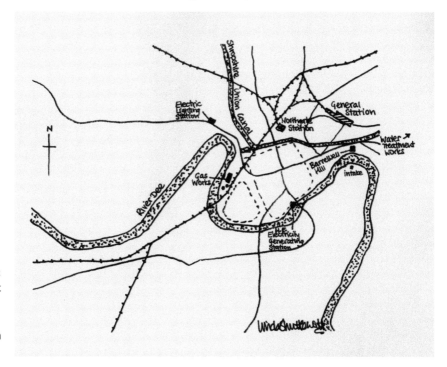

Plan of utilities & transport links in the early twentieth century.

Many rivers in industrial areas become too polluted by effluents to be usable for water supply, but Chester provides a notable exception to this problem. This was possible because of the relatively few troublesome effluents in the River Dee catchment upstream of Chester. In 1826 the Chester Waterworks Company (CWC) was established and by 1827 there was a steam engine at their Riverside Works, Barrelwell Hill in Boughton, directly abstracting water from the Dee. This was replaced in 1877 by a larger pump from the Hydraulic Engineering Company. Nowadays, water is still drawn from the River Dee and treated at the waterworks in Boughton. The imposing tower there (see front cover) was designed by F. L. Bateman, consultant engineer to the company. Built in the Italianate style, it has been raised in height twice and at one time had a chimney on top. Originally two beam engines pumped water into it, but in 1913 they were replaced with a diesel pump. The tanks hold 250,000 gallons. The Dee has a complex regulation system to ensure that a continuous flow of water is provided. The balance of Chester's drinking water comes from a borehole at Plemstall, an artesian well 350 feet deep with an 8-inch-diameter pipe acquired by CWC in 1958. CWC was acquired by Dee Valley Water in 1997 ,who were in turn acquired by Severn Trent in 2018.

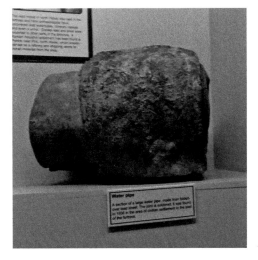

A Roman water pipe. (Grosvenor Museum)

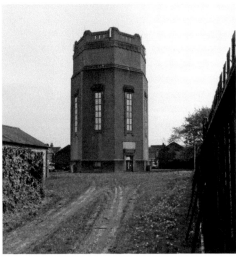

The octagonal concrete water tower in Handbridge was built by the Chester Waterworks Company in 1935. It is one of four towers in the supply area.

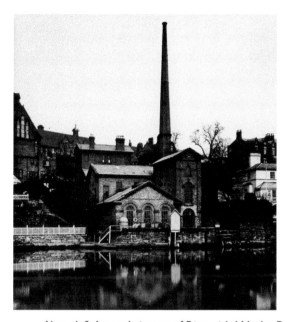

Above left: An early image of Riverside Works, Barrelwell Hill, shows the chimney still in situ for the 24-hp beam engine housed in the taller building. (CHH)

Above right: There are now four centrifugal pumps moving the raw water from the suction wells fed by gravity from the intake across the river.

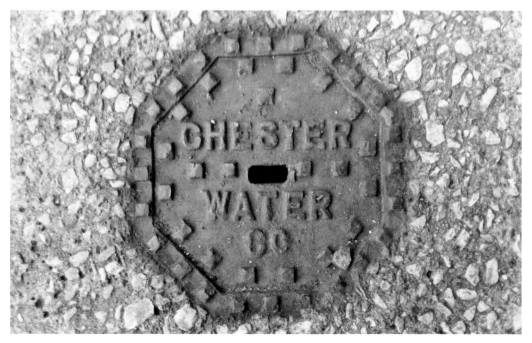

A Chester Waterworks Company stop tap cover. The company was formed in 1826 and was bought by Dee Valley Water in 1997.

ELECTRICITY SUPPLY

The city council's Electric Lighting Station in Crane Street started operation in 1896. A direct current of 210/420 volts was supplied by means of steam generation. In 1913 40 per cent of the city's electricity was supplied by a new hydroelectric generating station built on the site of the Dee Mills. After the acquisition by the council in 1922 of the government-owned power station at Queensferry, the area supplied was extended beyond the city boundaries, and by 1930 this municipal undertaking supplied an area of 144 square miles around Chester. Costs were kept down by avoiding investment in modernisation, and the long overdue transfer to alternating current in 1930 increased electricity bills by 33 per cent. Although from 1932 some power was bought from the new National Grid, by 1939 the enterprise was in profit again, and able to reduce its prices. The hydroelectric station continued in operation until 1946, when it produced just 2 per cent of the power used in the city.

The Electric Lighting Station in Crane Street started operation in 1896. A direct current of 210/420 volts was produced by means of steam generation. The frontage of the building was saved and is incorporated into a new development.

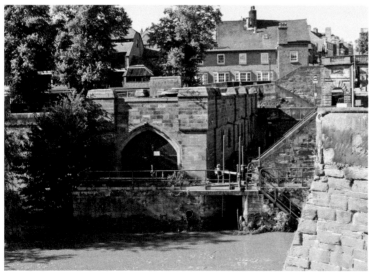

The hydroelectric power station built in 1913 on the site of the old Dee Mills. Recently it has been proposed to reopen it again to generate power using an archimedes screw.

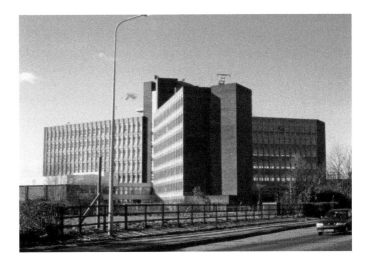

Manweb began building a new headquarters in Sealand Road in 1968 in a large group of buildings designed by Stroud, Nellis & Partners and dominated by a seven-storeyed Y-plan block. (Len Morgan collection)

Manweb was the regional electricity supplier and distributor for Merseyside, North Wales and parts of Cheshire. It was originally created in 1947 as the nationalised Merseyside & North Wales Electricity Board in the Electricity Act 1947. Manweb was privatised in 1990 to become Manweb plc, and in September 1994 the company announced plans to slash five hundred jobs in the workforce. It was purchased by Scottish Power in January 1996 and subsequently become SP Manweb plc. The Manweb name continued to be used alongside the Scottish Power logo on home and retail publications until the middle of 2007, when it was replaced by 'ScottishPower'. It is now part of SP Energy Networks, itself a subsidiary of the Spanish energy company Iberdrola.

THE CHESTER GASLIGHT COMPANY

The Chester Gaslight Company was formed in 1817 by a deed of settlement and the undertaking remained a non-statutory company. The works were situated in Cuppin Street and were built by Samuel Clegg. Pressure from the Chester Watch Committee and public dissatisfaction with costs due to a monopoly led to a number of attempts to establish a rival undertaking in the town. A complete reorganisation of the works was carried out in 1845 in an attempt to improve efficiency and bring down costs. In 1850 a rival company known as the Chester Gas Consumers Co. tried to establish itself, although this venture failed to raise enough capital to launch properly.

In 1851 an engineer from Birkenhead gasworks, Samuel Highfield, established a second company and built a gasworks at Roodee on the outskirts of Chester. The Roodee Gas Co. was soon sold and by 1855 the two companies had commenced negotiations with a view to amalgamation. The Chester United Gas Co. was formed in August 1856 with E. G. Salisbury, formerly of the Roodee Gas Co., as chairman. Salisbury, who had been a driving force in the amalgamation, was a barrister and Liberal MP for Chester between 1859 and 1865. The Roodee works were rebuilt in 1880 and a series of Acts of Parliament extended the area of supply to the surrounding villages. In 1949, the company was vested in the North West Gas Board.

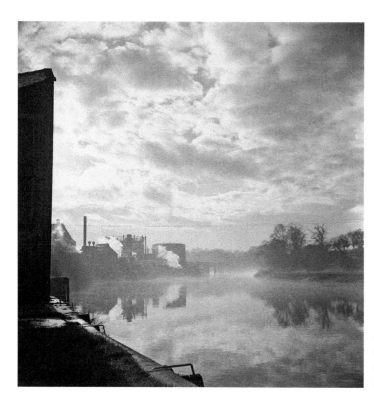

A 1950s view from Crane Bank of the riverside gasworks beyond. (CHH)

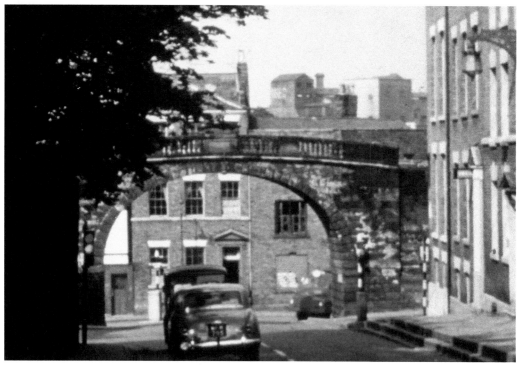

The view down Watergate Street shows the size of the gasworks. (Len Morgan collection)

TRAMWAYS AND BUSES IN THE CITY

The Chester Tramways Company built a horse-worked tramway from the General station to Saltney. The authorised capital was £32,000, with a further £8,000 by loan, and the directors included Philip Eberle, Thomas Wright and Miles Mason, all of whom were connected with the Liverpool United Tramways Company or the Liverpool Conveyance Company. In September 1878 it was reported that a contract had been let for the construction of the line, with cars, horses, stables and other equipment; it opened the following year. The tramway was taken over by the Corporation in 1902 and converted to a narrower-gauge (3-foot 6-inch) electrified line. In 1906 a second line to Boughton was opened. The system closed in 1930 and the Corporation changed to operating bus services in Chester. To comply with the Transport Act of 1985, the bus operation was transferred to a separate company in 1986, and it continued to trade as Chester City Transport until rebranded as 'ChesterBus' in April 2005. In July 2006, Chester City Council placed the business up for sale and it was sold in 2007 to First Chester & The Wirral with eighty-four buses.

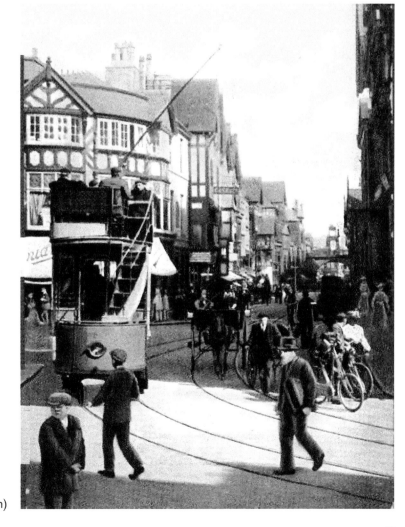

Electric tram rounding the Cross. The 550 volts of DC current was supplied by the hydroelectric station. (S. C. Jenkins collection)

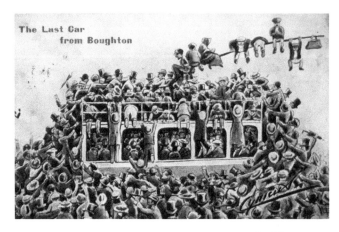

Cartoon showing overloading on the last tram. (Len Morgan collection)

Tramway track and points are still extant at the site of the old depot off Station Road. Student accommodation has now been developed on the site.

A relic of the tramway era: a wall-mounted ornate iron 'rose' that supported the overhead wires on Eastgate Street.

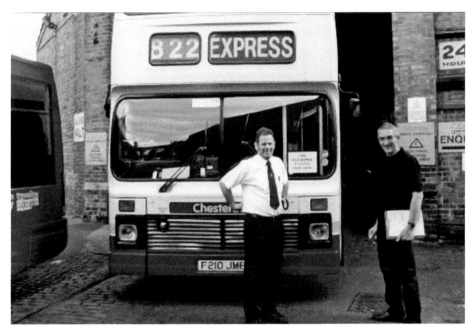

Driver Stephen Davidson (he 'usually gets called Steve') about to take out a ChesterBus Leyland Olympian (for the enthusiast, fitted out by Northern Counties) from the depot (note tram tracks) in 2006. Steve was made redundant from Shotton steel in 1980. The Job Centre sent him for an interview as a conductor in the days buses still had them. The interview didn't happen but he was offered the job, did the six weeks driving course and now works for Arriva on services to Mold & Connah's Quay. (Laurence Wheeler)

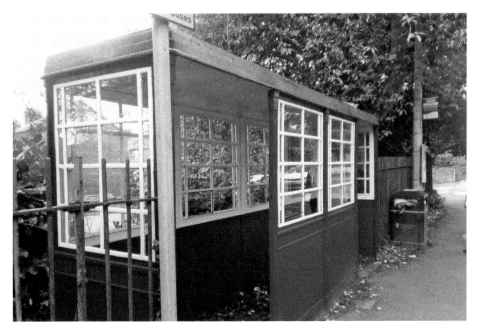

Original Chester City Transport bus shelter in Boughton.

CROSVILLE MOTOR SERVICES

Transport was an important source of employment in Chester, and in 1951 there were some 2,000 railwaymen, and 1,000 employees at Crosville Motor Services – the regional bus company based in Chester. The Crosville Motor Company was formed on 27 October 1906 by George Crosland Taylor and his French business associate Georges de Ville with the intention of building motor cars. In 1909, Crosville commenced its first bus service between Chester and Ellesmere Port, and by 1929 Crosville had consolidated its activities in an operating area covering the Wirral and parts of Lancashire, Cheshire and Flintshire. Later that year the LMS railway bought the company. A series of complex mergers occurred with Crosville ceasing operation in 1989.

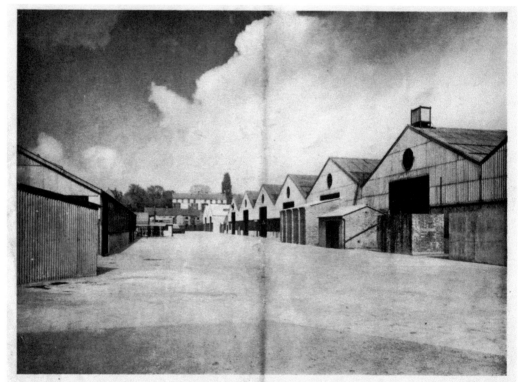

GENERAL VIEW OF SEALAND ROAD WORKS, WITH BODY AND PAINT SHOPS ON THE RIGHT, ELECTRICAL SHOP ON THE LEFT
Page Twelve

The Crosville Workshops on Sealand Road in the 1930s. (CHH)

Crosville's head office on New Crane Street in 1970. (CHH)

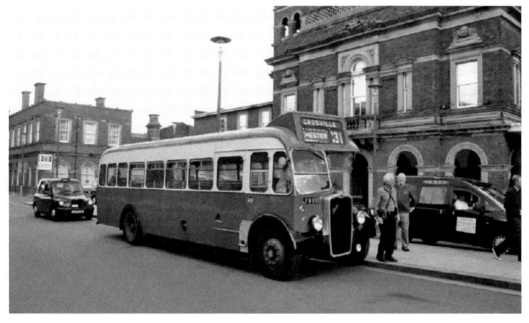

Crosville Bristol L bus outside the railway station in service from 1951 to 1970, seen here in later preservation days. Buses of this model were built from 1938. (Robert Griffiths)

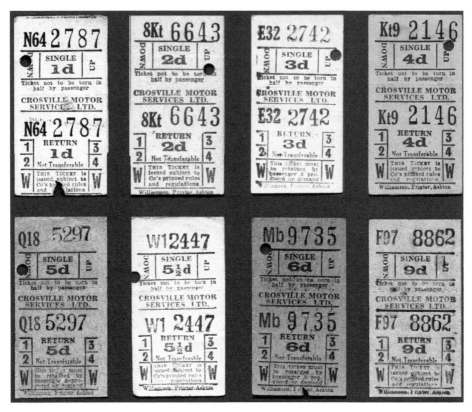

An array of Crosville tickets.

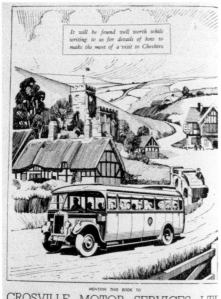

The delights of the nearby Cheshire villages are extolled in this Crosville advertisement. (Len Morgan collection)

LATER INDUSTRIAL DEVELOPMENT

At the turn of the nineteenth century there was a wide transition in the economy from small-scale production to business concentration and industrialised methods. This trend weakened the city's manufacturing base and was only partly offset by developments in a limited number of modern industrial concerns. Between 1871 and 1911, for example, the number of workers aged over twenty in metal manufacturing in Chester increased from 735 to 1,110 – a rise of 53 per cent. Nationally, however, the increase was around 130 per cent. The successful firms were those that were able to take advantage of new national or regional markets. However, due to increases in areas of employment other than manufacturing, Chester's unemployment rates were among the lowest in the country until the national economy began to falter in the mid-1960s.

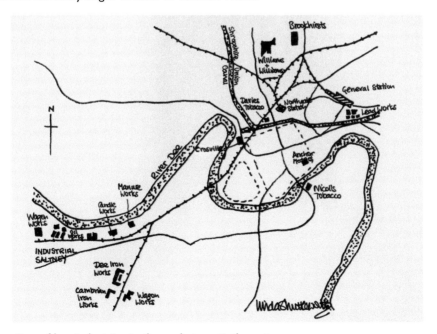

Location of key industries in the early twentieth century.

BREWING AND THE CHESTER NORTHGATE BREWERY

Brewing provides an example of an industry that has experienced many changes in terms of organisation and production methods. In 1871 there were thirteen individual breweries in Chester, of which seven appear to have been small breweries located at pubs. All of the others had ceased trading by 1909, leaving only the Northgate Brewery in operation. The two other commercial breweries, Seller & Co. and Bent's Lion Brewery, were sold to larger concerns and closed as breweries.

The Northgate Brewery had been founded in 1760 at the Golden Falcon Inn. A new brewery complex was built on the same site in the 1850s on Northgate Street and the undertaking was registered as a limited company in March 1885. By 1891 the Chester Northgate Brewery owned twenty tied houses in Chester and numerous others within a 15-mile radius from the city centre. It was acquired by Greenall Whitley & Co. Ltd in 1949, together with around 140 tied houses. Brewing ceased in 1969 and the brewery buildings were demolished in 1971 and a modern office block known as Centurion House was erected on site.

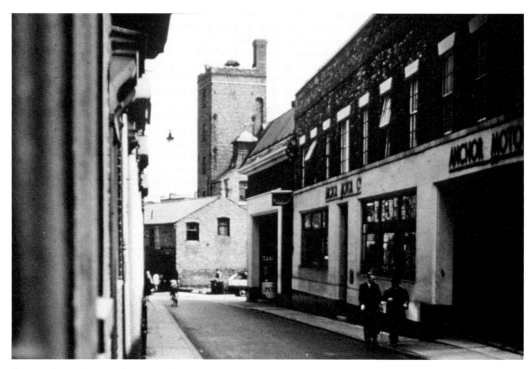

A view down Pepper Street before widening with Anchor Motors on the right and Bent's Lion Brewery central. The brewery was founded in 1642 and was taken over by Bent's Brewery of Liverpool in 1902. (Len Morgan collection)

Right and below: Bent's closed the brewery soon after purchase but it continued as a depot until demolition in 1969. These two photos show the famous Lion before and after placement on the replacement car park.

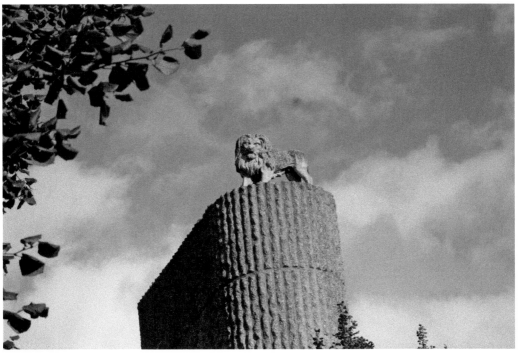

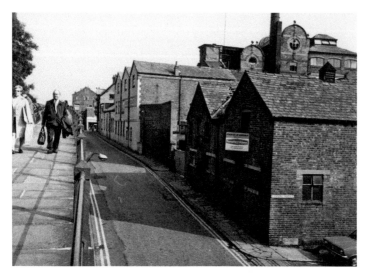

A view from
the city walls
showing Northgate
Brewery awaiting
demolition. (CHH)

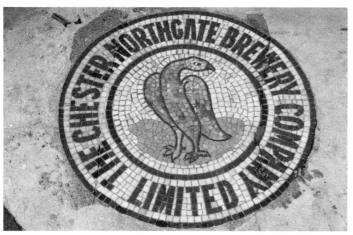

Northgate Brewery
logo preserved in a
mosaic at the rear of
Centurion House.

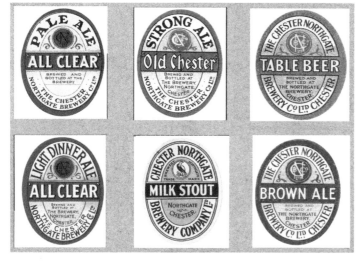

A selection of
Northgate Brewery
bottle labels.

Above left and right: In 1871 there were seven pub breweries in Chester, but these subsequently disappeared. Richard 'Sedge' Sedgewick is one of a new generation of pub brewers at work in the cellar brewery of the Pied Bull. The brewery has been operating since 2012 and Sedge has been brewer there for the past three years. He loves brewing, hopes to win a CAMRA award for his brew next month and sees the future of brewing in small-scale operations.

TOBACCO

Clay pipes were used to smoke tobacco until cigarettes became fashionable during the First World War. Chester was the centre for a once-flourishing clay tobacco pipe industry. The earliest clay tobacco pipe kiln ever found in Britain has been discovered in Chester. Tobacco manufacture was a legacy of the city having been an active port. In 1910 there were five tobacco manufacturers in Chester, two of which were large concerns – W.T. Davies & Sons of Canal Street and Thomas Nicholls & Co. of Deeside Mills, Handbridge. The former, established in 1860, was already in the ownership of Imperial Tobacco, an example of national firms strengthening their direct involvement in the local economy. Tobacco and snuff making were the only local industries providing a significantly growing number of jobs for women.

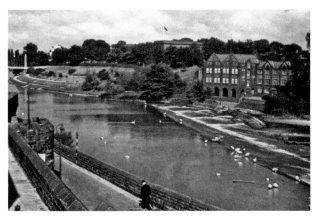

Nicholl's tobacco and snuff mills remained in operation until 1954 when it closed and the site was acquired by the city. The buildings were demolished in the mid-1960s and replaced by flats.

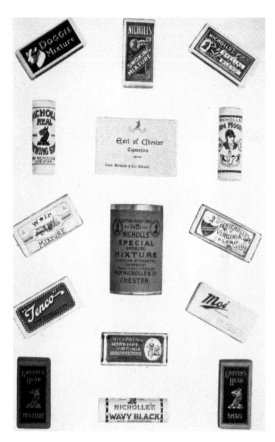

Packaging for some of Nicholl's products.

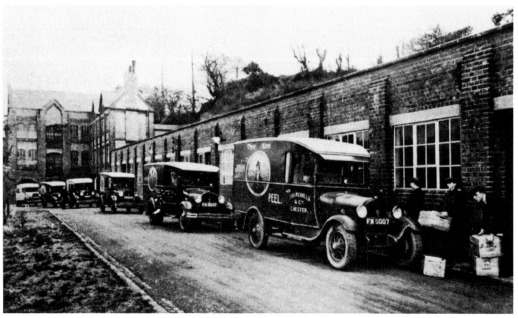

Delivery vans outside Nicholl's in 1932. (CHH)

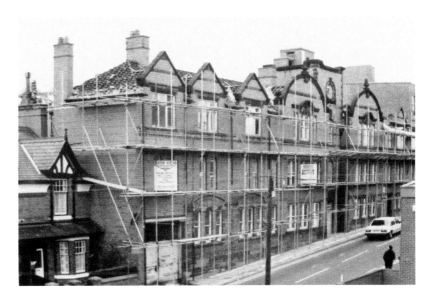

Davies' tobacco mill on Canal Street was used as a control centre during the war and was later owned by a seed merchant.

ENGINEERING

There was some development of engineering in the twentieth century. Two new large engineering works were both situated in the north of Chester, one of these being Brookhirst Switchgear Ltd. This was an electrical engineering company that was established in 1898 by John Arthur Hirst and Percy Shelley Brook. Neither of the original partners were Cestrians, and the firm's location in the city was due solely to Hirst's enlightened view that Chester was a better place to live than his native Manchester and would provide 'gentle and pleasing conditions' for his workers. The original premises were in Victoria Road, later moving to George Street and subsequently to Newry Park. It had two sections: one for the manufacture of direct-current control gear and the other for the manufacture of alternating-current control gear and a range of small power control gear for motors up to around 10 hp. Such was the firm's success that the works had to be expanded within two years, and it was extended again in 1915 and 1917.

The firm was at the forefront of technical development in the electrical industry during its early years, due mainly to Hirst's ability. By the 1920s major orders from abroad were being received, especially from foreign mercantile navies. An example of their switchgear can be seen on HMY *Britannia*. In 1943 Metal Industries acquired Brookhirst Switchgear; however, it wasn't until 1960 that they merged it with their other subsidiary, Igranic Electrical Ltd. The sales headquarters moved to Bedford. In the late 1960s, the Northgate works in Newry Park were closed, but production continued at Bedford under the name Brookhirst Igranic Ltd.

Neville Shallcross served his apprenticeship with the company from 1957 to 1962. He said that most of the workers were from the Hoole and Upton areas, and many were related to each other and became 'attached' to the company. Neville describes how one man working away in Singapore become quite emotional seeing the Brookhirst 'bean' sign on a piece of machinery. Neville also remembers that the company provided good recreational facilities for staff. He played for the football team, which took part in sporting weekends, visiting the associated factory in Bedford.

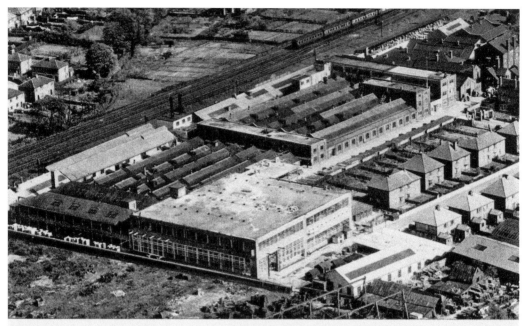

Newry Park, 1950

Brookhirst's Switchgear factory, Newry Park, 1950. (CHH)

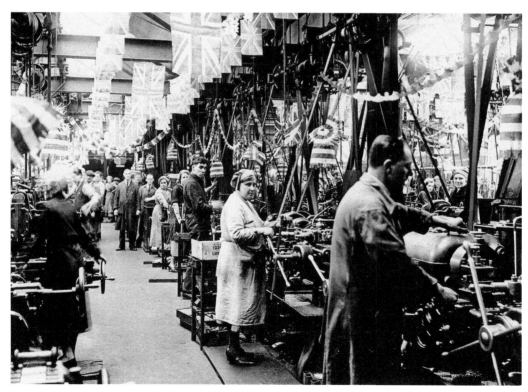

Brookhirst's Switchgear factory decorated with bunting for the coronation in 1937. (CHH)

A Brookhirst product
exhibited at the Museu
de Electricidade, Madeira.
(Grace's Guide to British
Industrial History)

The Brookhirst 'bean' sign. (Grace's Guide to British Industrial History)

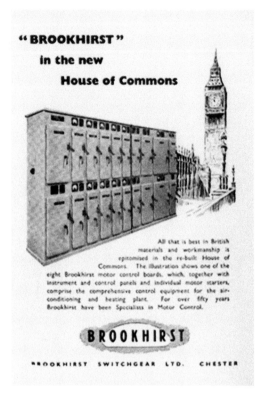

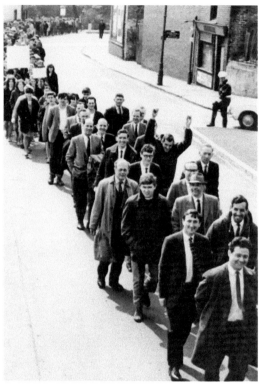

Above left: Brookhirst advertisement proudly proclaiming the use of their switchgear in the House of Commons. (Grace's Guide to British Industrial History)

Above right: Brookhirst's workers May Day redundancy protest march in 1968 on Victoria Road. (CHH)

Williams & Williams (W&W) window manufacturers was formed in 1910 and became a public company in 1928. The undertaking was based in the Reliance works on Liverpool Road. On the Chester site there were three buildings: Sash, Reliance and Cottage. The founders were the proprieters' sons of an earlier company, Williams & Gammon, who made wrought-iron windows. The company specialised in the manufacture of metal window frames, doors and patent glazing, although other equipment was made during the two world wars. Following a munitions explosion an ammunition box designed by W&W was inspected by Churchill, then the Minister of Supply, and a quarter million were ordered from the company in the First World War. 'Jerry cans' were produced during the Second World War and many other products too, including parts for the Mulberry Harbour. Over the years there were many developments and mergers. In 1934 Allan Williams broke away and started the Rustproof Metal Box Company in Saltney. There were small satellite companies in South Africa and Nigeria. The latter one closed due to the Biafran War. In 1968 W&W 'merged' (staff saw it as a takeover!) with competitors Heywood Helliwell of Huddersfield. Diversifying, they moved into the 'home improvement market' under the name of Apollo Windows. By 1961 the firm had 6,000 employees worldwide, including 2,750 in the UK. The Chester factory closed in 1996.

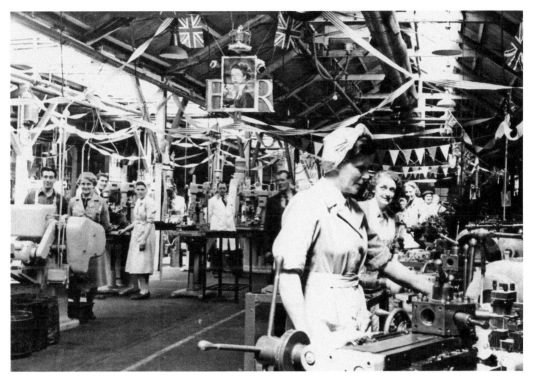

Williams & Williams Reliance Works decorated for the Queen's Coronation on 1 June 1953. (CHH)

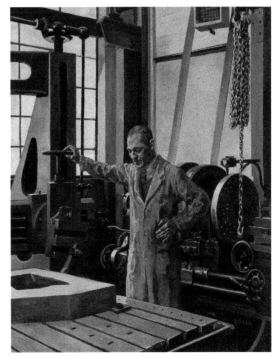

Ethel L. Gabain had thirty-eight paintings commissioned by the War Office during the Second World War. Perhaps more familiar with painting famous actresses, she depicts Jack Roberts in the tool room at Williams & Williams machining metal for the manufacture of jerry cans. (Grosvenor Museum)

Above left and right: A pair of W & W advertisements illustrating the international 'reach' of the company.

Colin Pinches, two of his brothers and his dad all worked for the company. Colin mainly worked in the drawing office from 1951 until 1996, producing working drawings for the shop floor to manufacture from and finishing his career in the design department. He said that 'the Company facilities were good but wished the pay had been better'.

MOTOR VEHICLES

In the early days of motoring there were several small manufacturers and dealers in Chester. The Westminster Coach & Motor Car Works was sited on Northgate Street near to the Town Hall. Its elaborate terracotta façade is dated 1914. However, it appears to be built on an earlier structure for the carriage builders J. A. Lawton & Co. (who also had premises in Liverpool and Cricklewood) that was burnt down on 1 July 1910. Their building was two storeys high, but otherwise apparently similar to the existing design. Cars were sold on the site until the 1970s, and the City Library was built behind the façade to an award-winning design by the Cheshire County Council Department of Architecture in 1981–84. The site will become a key part of One City Place.

As mentioned earlier, the Crosville Motor Company was originally founded as a motor-manufacturing firm, although in reality car production was confined to a few vehicles made by George Crosland-Taylor between 1906 and 1910 using parts imported from France. Five cars were produced bearing the Crosville name, but only two appear to have been built in Chester. From 1910 the firm concentrated on running its successful road transport business.

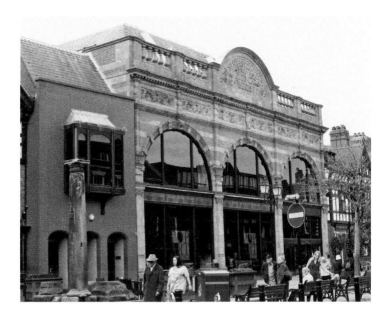

Westminster Coach and Motor Car works frontage on Northgate Street.

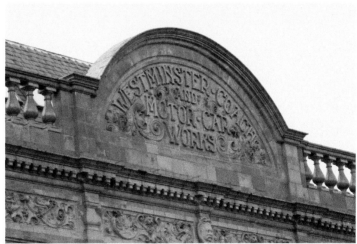

The Anchor Motor Company built a brand new building in front of the New Connection Church on Pepper Street, and repair workshops in Park Street. The church, which dated back to 1836, had been designed by William Cole (1800–92) who had been a pupil of the eminent local architect Thomas Harrison (1744–1829). This place of worship was closed shortly after the First World War and thereafter the motor company adapted the building for manufacturing purposes and added a new façade. The company built and sold cars and went on to manufacture aircraft fuselages and Spitfire wings during the Second World War. After the war they briefly became a successful manufacturer of model aircraft engines, although this activity ceased when they returned to military manufacturing (portable generators) during the Korean War (1950–53).

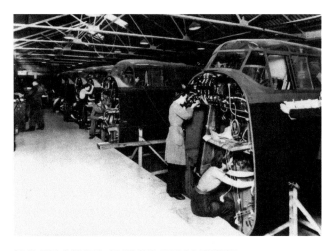

The Anchor Motor Company Limited assembling aircraft fuselages in 1939 as part of the war effort. (CHH)

POST-WAR DEVELOPMENTS

Shortly after the Second World War, in 1949, the Corporation provided a site for light industry at the Sealand Estate to the west of the city centre, which initially covered an area of 30 acres. Eleven businesses were located there in 1960, and by 1974 there were seventy firms employing up to 2,000 people. However, most of these employees were involved in distribution services rather than manufacturing.

Further sites for new industry were established along Sealand Road, first in an extension of the Sealand Industrial Estate, next by the creation of the Stadium Industrial Estate on the opposite side of the road, on the site vacated by Chester City Football Club in 1990, and finally at Chester West Employment Park, an 84-acre greenfield site further out on the south side of the road. The first businesses to set up there included an American printing firm, New England Business Stationery; a regional computerized stock-control centre for Boots; a printing works for the Thomson International newspaper group; and offices for the Pearl Assurance Company.

The Sealand Industrial Estate has become more of a retail park. Some of the early buildings still exist.

CHANGES IN PATTERNS OF COMMUTING AND EMPLOYMENT

In the early 1950s the city still had some older established manufacturing concerns like the leadworks and two tobacco companies. However, they only employed a total of around 500 people, whereas newer, larger, and more modern enterprises such as Brookhirst Electrical Switchgear, Williams & Williams and its offshoot, Rustproof Metal Windows Ltd of Saltney, employed over 3,500 workers between them. The Hydraulic Engineering Company was still an industry leader specialising in the fields of hydraulic presses and high-speed self-contained pumping units.

In recent years however, Chester's workforce has increasingly been supplied from outside the city boundaries. Commuters into the county borough accounted for 51 per cent of the total employed by 1971. At the same time there was a daily flow of commuters who travelled from Chester to work elsewhere, especially in the industrial plants of nearby Ellesmere Port and Deeside – 31 per cent in 1971 of the employed residents of the county borough worked outside its boundaries.

The Chester Assay Office on Goss Street, which closed down in 1962, had provided a centuries old link with passed industry. Precious items have been manufactured and sold in Chester since the ninth century and assaying began in the fifteenth. The mark for Chester is a shield bearing the town's arms – a sword and three sheaves of wheat. Chester was granted an official Assay Office by an Act of Parliament in 1700. (Len Morgan collection)

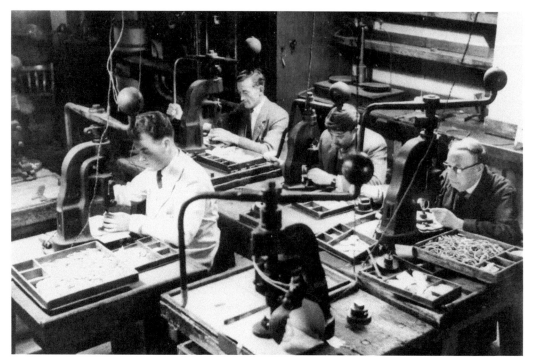

A glimpse inside the assay office around 1960. Objects made of gold, silver, etc., are given an official mark to indicate their purity. (CHH)

Some of the industries that provided employment for Chester residents were based nearby; for example, Saltney, straddling the Flintshire border, was Chester's own 'miniature Black Country' with a long history of manufacturing including Wood's chain works, oil and railway works. Shotton steelworks was opened by John Summers in 1896, and although the size of workforce has been reduced the plant remains in operation as part of Tata Steel Europe.

The other main industrial firms in the region include Vauxhall Motors, which started as Vauxhall ironworks in London in the 1850s. They produced their first motor car in 1903, moving to their main site in Luton in 1905. Vauxhall purchased 393 acres of land at the Hooton airfield in Ellesmere Port in 1961 to establish their plant. ICI and the petro-chemical industries are well-established at Ellesmere Port. Shell built their first tankage installation in 1922 here and now run the country's largest refinery at Stanlow. Urenco operate the nuclear enrichment plant at Capenhurst, and a newcomer, Toyota Motors are based near Wrexham.

The Airbus factory at Broughton was founded in 1939 as a shadow factory for Vickers-Armstrong Limited to produce Wellingtons, Lancasters and other aircraft types. After the war the factory was taken over by de Havilland who used it to build various aircraft, including the Mosquito and the Comet. It is now part of the Airbus Consortium.

MODERN TIMES

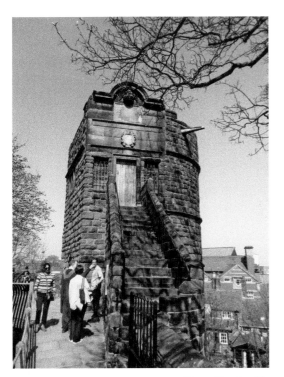

Above left: The Phoenix or King Charles Tower was the meeting place of several guilds. The carved phoenix above the door, with the date 1613, was the badge of the Painters. The medieval guilds controlled work within the city walls. Here a freeman is acting as a guide in modern times.

Above right: These three old arches, dating from around 1200, are thought to be Britain's oldest surviving shopfront. In modern-day Chester the ground floor is now a 'baby' shop and estate agent.

I n the modern world of Chester old traditions are still cherished. Today there are still twenty-three guilds, but few members now practice their company trade. New freemen are admitted each year at the Pentice Court ceremony held in the Town Hall. The Lord Mayor of Chester presides over the court. The guilds in the past often used to meet in the Phoenix (King Charles) Tower, then leased the old Holy Trinity Church from the 1960s to 2011. In 1992 the freemen and guilds decided to admit women for the first time.

Brookhirst, an industry-leading Chester company, was started by two able men and eight employees on Victoria Road. Having become Brookhirst Igranic Ltd, they were taken over by Cutler Hammer of Milwaukee in 1971. In 1978 they in turn were taken over by the Eaton Corporation, an American multinational power management company with 2018 sales of $21.6 billion and operational headquarters in Ohio. Eaton has approximately 99,000 employees and sells products to customers in more than 175 countries. While the Eaton board discuss multibillion-dollar deals in Ohio, the Brookhirst apprentices of 1959 have a 'whale of a time' meeting in the Bear's Paw to reminisce about the hat-trick scored in the interfirm match or the works dances – funny old world!

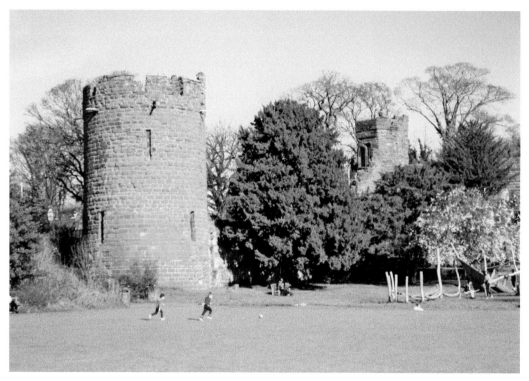

The fourteenth-century Water Tower now stands rather 'awkwardly' in gardens named after itself. It has now become an attraction for tourists.

The Virtual Reality (VR) Centre on Northgate Street was opened in September 2017.

Matt, the manager of the VR Centre, believes that virtual reality can play an important role bringing more customers back onto the British high street and helping to reduce the decline that we have seen as a result of online shopping in recent years. He's proud of the part it plays as an excellent entertainment addition.

Scottish Widows, who owned the Forum, sold the site to the Dutch bank ING, who had development in their sights. They launched an ambitious plan for the Northgate area for which they obtained planning permission in 2005. Due to the banking crisis of 2007–08, however, they were not able to continue with it and in 2012 the Cheshire West & Chester Council ended the contract and developed an ambitious One City Plan. The first projects were the Chester Bus Interchange, King Charles Tower Gardens and Storyhouse, all of which were opened in 2017 – the latter was an official opening by the Queen and Duchess of Sussex in May 2018. One City Place in the Northgate area is now out to consultation and it is planned that the first stage will be open by 2021. The retail stages are planned for later in the process, if at all because of the rapid rate of change of the 'high street'.

Storyhouse has an arts theatre, an arthouse cinema, library and café and was developed from the Odeon Cinema, which was built in the art deco style and opened in 1936.

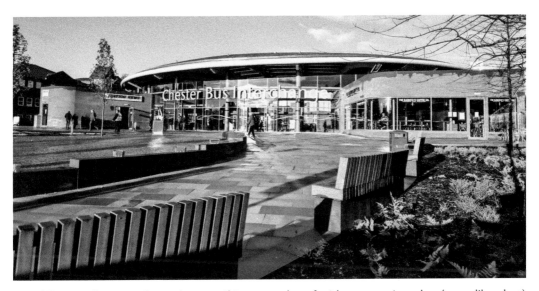

The new bus interchange has a striking curved roof with an organic sedun (moss-like plant) roof. It was built on the Gorsestacks, the site of the old cattle market. (CWAC)

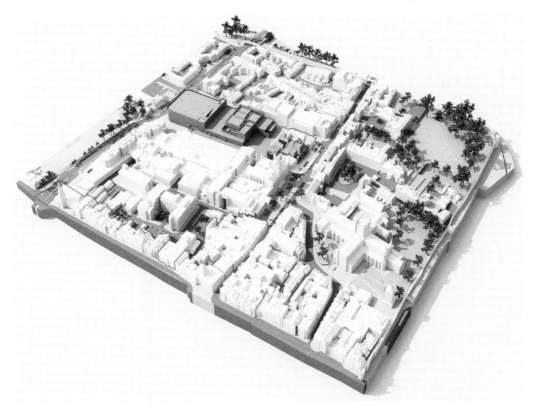

One City Place, part of the Northgate development in the north west of the centre, is now out to consultation and it is anticipated that the first stage (shown in grey) will open in 2021. It is to be a new leisure, residential and shopping development. (CWAC)

POSTSCRIPT

Nathaniel Hawthorne (1804–64), the American novelist, visited Chester and commented that there is 'no place more curious'. We have seen in these pages how the world of work had an unusual impact on Chester. The arrival of new peoples brought great change and new direction. At the same time there is a homeostasis about the place. Chester has experienced its share of hard times: the devastation after the Conquest, the impact of the Civil War siege and the losses in both world wars. The relatively prosperous Stuart and Tudor times had a lingering continuity about them. In some ways the 'hanging on' to old ways held back the industrial development of Chester.

Chester has long been a frontier town and has had to 'guard its back'. It formed a springboard for trade and campaigns in Wales and Ireland. Perhaps the homeostasis Chester quietly maintains has given the Cestrians a resilience that has carried them through. We have seen that the 1700s were a pivotal time of change and also the manner in which Chester reinvented itself to become a modern city, and constantly does so today.

Victoria Glazer demonstrated the resilience of the Cestrians. She led a renaissance of the market in 2018 by opening a café and stall specialising in her parent's bakery bread. Other food and drink outlets soon followed and together they created a bohemian atmosphere. Victoria sees the market now as the 'soul' of the city.